CLINTONVILLE AND BEECHWOLD

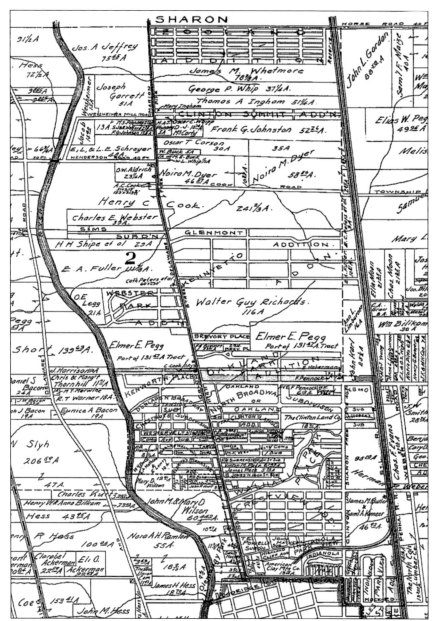

This 1910 map from Modie and Kilmer's *Folio Atlas of Franklin County* shows Clintonville property ownership and the beginning of residential subdivision from the southern border of Clintonville to the border between Clinton and Sharon Townships along present-day Morse Road. In 1920, most of this land was not yet part of Columbus.

On the cover: Life was a picnic in Clintonville back in the days when Clintonville's Olentangy Park was *the* destination spot of central Ohio. The park, a picturesque venue with amusement rides, world-class entertainment, a huge pool, and a zoo, hosted small and large picnics throughout the summer. This private picnic was held in the mid-1920s. (Courtesy of Clintonville Historical Society.)

IMAGES
of America

CLINTONVILLE AND BEECHWOLD

Shirley Hyatt

ARCADIA
PUBLISHING

Published by Arcadia Publishing
Charleston SC, Chicago IL, Portsmouth NH, San Francisco CA

Printed in the United States of America

Library of Congress Catalog Card Number: 2008932968

For all general information contact Arcadia Publishing at:
Telephone 843-853-2070
Fax 843-853-0044
E-mail sales@arcadiapublishing.com
For customer service and orders:
Toll-Free 1-888-313-2665

Visit us on the Internet at www.arcadiapublishing.com

This book is dedicated to the first families of Clintonville

CONTENTS

ACKNOWLEDGMENTS

Thanks to all those people who allowed me into their homes and businesses, told me their Clintonville stories, and shared their photographs with me (and by extension, with the readers of this book). There were, by rough count, over 200 of you. I am awed at your generosity and trust.

Thanks also to the Clintonville Historical Society for opening its collection to me. President Algy McBride has done a yeoman's job of preserving the history of the community for the community.

This project represents but a drop in the bucket of the contribution that the staff of the Genealogy, History, and Travel Department of the Columbus Metropolitan Library has made to the residents of Columbus. The department's expertise and collection of materials on the history of Columbus have been an invaluable resource. I owe special thanks to Nick Taggart, who responded to my e-mail inquiries with speed and thoroughness.

Several other behind-the-scenes people contributed greatly. Nancy and Harry Campbell encouraged me to undertake this project, answered innumerable questions, and were an ever-present source of helpful advice. Alex Campbell tutored me about local transportation history, shared his excellent photograph collection for use in this book, and reviewed the results. Lynn McNish photographed buildings that I was unable to find images of by other means and thereby helped to fill out this history.

My editor Melissa Basilone gave me, an Arcadia Publishing newcomer, the opportunity to write the book and provided me with silver-tongued guidance through to the project's completion. I am grateful.

Last but hardly least, thanks, Terry, for your patience and support and for being such a good sport amid the temporary loss of your hiking, cycling, paddling, camping, cooking, and traveling partner. You've been great.

INTRODUCTION

This is the story of Clintonville and Beechwold. Balser Hess, a cobbler, tanner, and Revolutionary War veteran, was one of the first pioneers to arrive in Clinton Township. Hess came to Ohio with his family in 1800 and bought 320 acres of land along the west bank of the Olentangy River. His first house, a log structure, was a common stopping place with travelers. Balser died in 1806 and was the first person to be buried on the grounds that became Union Cemetery. His family probably made some of the first improvements to the area.

David Beers arrived in the area in 1802; John Wilson arrived in 1804; Roswell Wilcox came in 1805; the Coe family arrived in 1807; Thomas Bull, Isaac Brevoort, John Smith, and Philologus Webster and their families came in 1812; and Roswell Cooke and John Buck arrived in 1815. These men became pillars of their albeit rural community, holding township offices, organizing churches and schools, and improving the land.

Bull purchased over 680 acres of land located around what is now High Street and North Broadway Street, and when he died in 1823, he left the land to his children. His son Alonson Bull subdivided some of the land he inherited near the corner of Orchard Lane and High Street to attract "mechanics," including a harness maker, a blacksmith, a carpenter, and other craftsmen. By 1847, the business area had a post office of its own, called Clintonville because it was in the center of Clinton township.

For many years, Clintonville remained a small hamlet between the bustling towns of Worthington and Columbus, consisting of farms, vineyards, orchards, those "mechanics," plus a brickyard. Then in the 1890s, improved transportation—most significantly, the electric streetcar—allowed people to work in the city yet live elsewhere. Families who could afford it made the great exodus from the city to the suburbs. And as people moved into the area north of the city of Columbus, the city itself moved with them. In 1870, the northern boundary of Columbus was at Arcadia Avenue. By 1910, the boundary had crept to Oakland Park Avenue. In short order in the 1920s, the boundary moved to Glencoe Avenue, to Glenmont Avenue, and then in 1927 to Rathbone Road near Morse Road. In the 1950s and 1960s, the boundaries marched even further north to the southern border of Worthington. Once upon a time, families moved to Clintonville because there they would find new houses, convenient public transportation, and friendly neighbors along with fresh air, meadows of wildflowers, deep-wooded ravines and a pristine fishing stream. A century later, the little hamlet had become a place of mature housing stock, commercial areas in need of occasional revitalization, manicured recreation areas, and widely divergent neighborhoods and people.

Like the trees that today provide Clintonville's renowned shady yards, the people who have raised children, worked, gone to school, and lived in Clintonville have very deep roots in the

community—memories, stories, pictures, souvenirs, and even graves. Those deep roots are what make Clintonville and Clintonville people so special.

And now, a few caveats.

A few readers may take issue with my inclusion of photographs of buildings that are not strictly within the Clintonville Area Commission jurisdictional boundaries established by city officials in 1975. Respectfully, I stand my ground. During Clintonville's development, its boundaries were never so distinctly demarcated. Clintonville is a neighborhood and will always be defined by the hearts, minds, and pocketbooks of its residents as well as by the local newspapers its residents read (the *Booster*). While the pictures do not wander very far afield, I do include some places and people as far south as Dodridge Street.

This pictorial history is, well, just that. The history I tell here is limited to the pictures I have been able to procure. As a result, I have left some things out. Luckily, there are some good sources for more detailed information about Clintonville's history, and these include: Nancy Pendleton's 1997 *Early Clintonville (and Grove City) and the Bull and Smith Families*; Mary Bowlin's 2008 compilation of Clintonville Historical Society newsletter articles, *Historical Clippings of Clintonville*; Nancy Campbell's 2006 National Register of Historic Places nomination for the Truman and Sylvia Bull Coe House; and *Clinton League Memory Books 1912–1953* at the Ohio Historical Society. A blog with some additional information about the places I write about here can be found at www.clintonvillehistory.com.

Some of my readers may be disappointed that their favorite photograph subjects are not in this book. I can only reply that it was not for want of trying. If you are aware of photographs of old (or merely former) Clintonville that are not found in this book, I encourage you to make archivally-responsible copies and give them to the historical society or the public library. There is no better way to preserve your history than to place quality copies in interested repositories, let people know they exist, and make the copies widely accessible.

One

DULCE DOMUM

According to a promotional brochure for Clintonville from the 1920s, "There are no railroads to cross, no factories or other objectionable features. The pure air blowing from the country side on the west gives all the allurements of country life with the comforts and facilities of a big city, including natural gas, electricity, city water, sewerage, and a 10-minute service on streetcars with time of 25 minutes to the center of the city. High water or floods hold no terror for residents here for the locality is 40 feet above the banks of the Olentangy."

With improved transportation and roads, one of the first housing subdivisions to be developed in Clintonville was East North Broadway in 1890 by James M. Loren and Herman G. Dennison. It was conceived as an elite elm-lined avenue of stately mansions on one-acre lots. It even had its own railroad depot and post office. Then the Crestview area was developed, the Oakland Park area, the Dominion Park addition, the Walhalla area, Beechwold, the Overbrook Drive area, Northmoor Place, Webster Park, and the Rosemary addition. Housing spread unabated until the Great Depression and World War II, and although the war stopped the building boom, as it stopped almost all domestic expansion, building picked up again in the 1950s.

In some respects, Clintonville could appropriately be renamed Johnsonville, as it was Charles F. Johnson who developed so many of the community's noteworthy neighborhoods in a succession of companies. There was the Columbus Land Company; Thompson, Johnson, Thompson Company; Dominion Land Company, then Crayton, Johnson Realty Company; the New Columbus Land Company; Charles F. Johnson Realty Company; Columbus Holding Company; Owners' Land Company; Bergman Realty Company; and the Beechwold Realty Company. Though Johnson did not reside in Clintonville, he made a lasting and positive impact on its residential neighborhoods.

Clintonville was one of Columbus's first modern suburbs that developed as better transportation expanded beyond the city core.

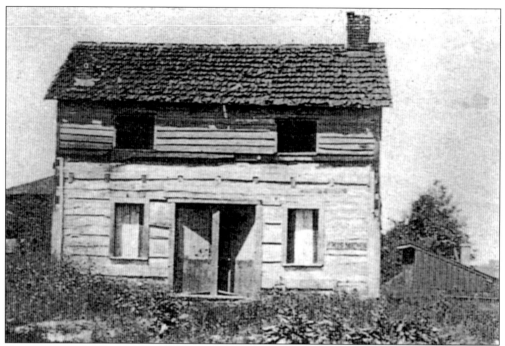

David Beers was a pioneer settler who traded with Native Americans and came to Ohio in 1802. His two-story log house, built around 1804, stood near the intersection of High and North (formerly called Mill) Streets. Beers died in 1850. The log house was moved in 1899 to 40 East Norwich Avenue by artists Herman and Conn Baker, who used it as a studio. (Courtesy of Marty Cottrill.)

Beers's cabin, mill, and livery became a bustling trading center, and in 1852, his sons Solomon and George platted North Columbus near High Street between Hudson and Dodridge Streets. Later Camp Thomas, a Civil War training facility, was established on Solomon's farm. Beers descendants report that this building, located on East Dodridge Street until the 1950s, served as barracks or a commissary for the camp. (Courtesy of Marty Cottrill.)

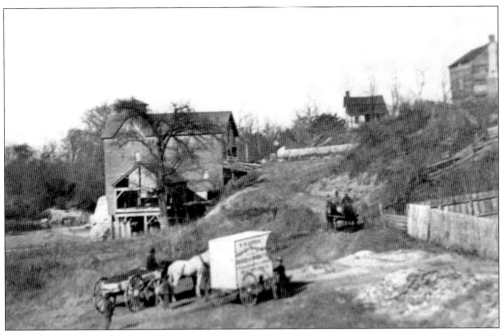

David Beers built the first gristmill in Franklin County in 1810 near his cabin just north of the current Dodridge Street bridge. The mill had several owners after Beers's death, including the father of poet John James Piatt. The Beers/Piatt Mill was one of the most picturesque spots in Ohio. The picture above, taken in 1880, shows the mill on the left and the Brown family farm on the right. The Brown family may have operated the mill during that general era. The picture of the mill below was taken around the same time. The mill burned down around 1902. (Courtesy of Judy Cohen.)

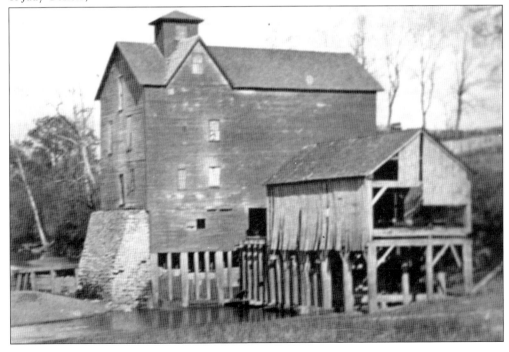

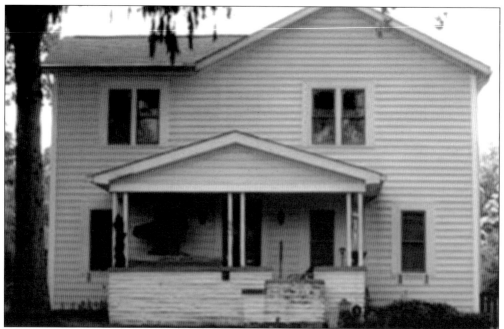

Dr. Nathan Thompson Bull was a son of Thomas Bull. His house was built in 1846 and located on what has become the northeast corner of High Street and East Como Avenue. The house was moved in the 1930s to a lot at 83 East Como Avenue. It has been significantly enlarged and modernized. (Courtesy of Nancy Campbell.)

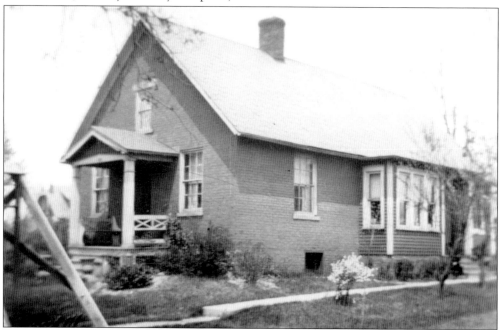

Thomas Bull's daughter Chloe came to the area with her husband, Isaac Brevoort, and son Henry around 1812. They built a log cabin along the Worthington pike. Brevoort died in 1814 while crossing the river. Henry stayed on and in 1850 built this brick home at 3620 High Street (shown here in 1920), behind the original cabin site. (Courtesy of Gordon Brevoort.)

This old home at 3338–3340 Wall Street just south of West North Broadway Street is said to have been owned by James Chestnut, who purchased 20 acres in the vicinity in 1863. The house was built between 1872 and 1903 and may have been subsequently moved to this location. Chestnut's tract of land was divided into 107 lots in 1895, according to Clintonville historian Nancy Pendleton. (Courtesy of Terry Miller.)

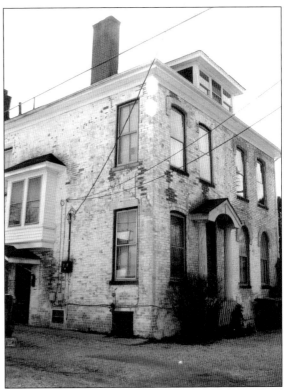

The Truman and Sylvia Bull Coe house at 75 East Lakeview Avenue is one of the few residences remaining from Clintonville's 19th-century community. It was likely built between 1880 and 1885 by Thomas Bull's granddaughter and her husband. The house, an example of late Victorian, Queen Anne-Eastlake-style architecture, is on the National Register of Historic Places. The photograph shows the house in the 1940s; it has since been renovated. (Courtesy of Brad Schwartz.)

Clinton C. Hollenback (1866–1930) was an early resident of Clintonville, a printer, and an early technology geek. He took many photographs of Clintonville and Columbus. He founded the Press of Hollenback, which published the *Columbus Medical Journal* and the *Columbus Press Post*, and cofounded the American Insurance Union. Hollenback's son Rand P. Hollenback founded the *Booster* newspaper. Rand's son Donal took over the newspaper at his father's death. (Courtesy of Columbus Metropolitan Library.)

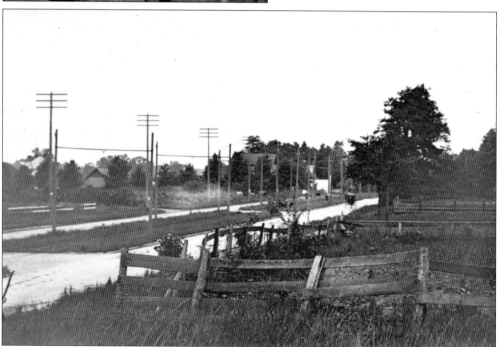

The Hollenback family moved to Clintonville around 1900. Clintonville was chiefly farmland at the time. Clinton C. Hollenback took this photograph near his house, and it shows what High Street looked like in the early part of the 1900s. (Courtesy of Edward H. Miller.)

The Hollenback homestead at 3134 High Street near the corner of California Avenue is shown on the right of this photograph. The camera was pointed west toward High Street and the Olentangy River. The farmhouse that soon housed the original Southwick Funeral Home is on the far left. (Courtesy of The Columbus Dispatch.)

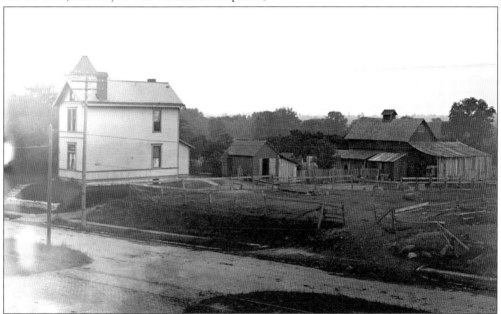

This handsome farmhouse was located at 3119 High Street, and when the photograph was taken in 1904, it was owned by dairyman William Kimball. In 1929 or 1930, Raymond L. Southwick purchased it, and the farmhouse became Southwick Funeral Home. In 1938, the undertaking business moved across the street to its present location at 3100 North High Street. (Courtesy of Edward H. Miller.)

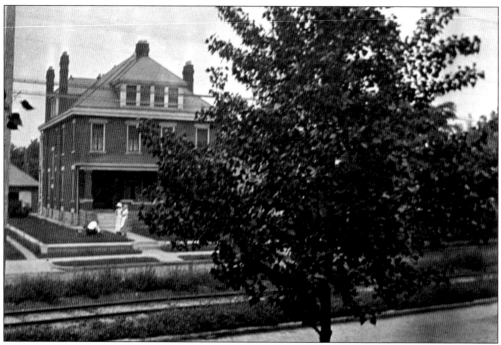

By 1910, when the photograph above was taken by Clinton C. Hollenback, this house at 3143–3145 High Street was built. The house still exists. (Courtesy of the Richard Dawson family.)

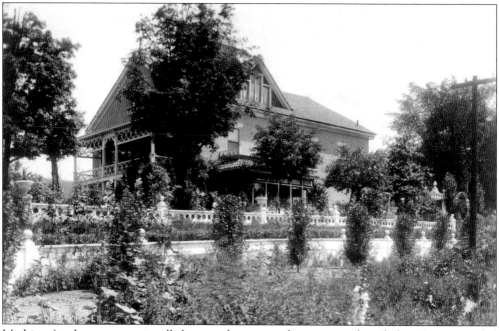

Mathias Armbruster, a nationally-known theater set designer, purchased the 29-acre wooded ravine now known as Walhalla. His purchase included Clinton Chapel. He had its graves removed to Union Cemetery and converted the house into his private residence. Armbruster's house served briefly as a speakeasy during Prohibition. Raymond L. Southwick purchased it in 1938, and it is now the Southwick-Good and Fortkamp Funeral Chapel. (Courtesy of Leeann Faust.)

William H. Scott (1840–1937) was a professor of philosophy and then president of the Ohio State University from 1883 to 1895. He lived in this house at 3451 High Street at the corner of Kenworth Road—now a parking lot for Kroger—after his retirement. The house was razed about 1984. (Courtesy of Amy Westervelt.)

This house in the North Broadway division was located at 3364 High Street on the southeast corner of North Broadway Street in 1897. Descriptions say it was a massive, fine brick building, standing back some 200 feet from High Street with large and spacious grounds, a driveway, and beautiful shade trees. (Courtesy of Nick Taggart.)

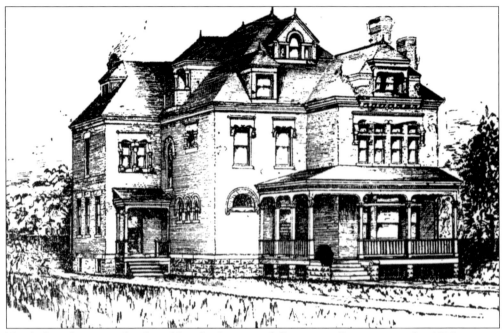

North Broadway was developed by the Loren and Dennison Company in the 1890s; it was intended to be the place to live, and it was. It had a small depot and post office at North Broadway's east end at the railroad track. This house at 242 East North Broadway Street was, according to the house's abstract, the second house built in the subdivision. (Courtesy of Gary Means.)

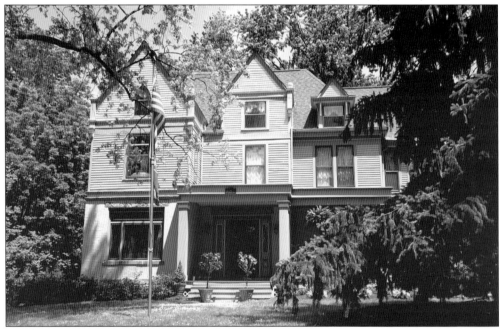

This house at 150 East North Broadway Street was built in the 1890s. The Ohio Department of Public Works owned the house from 1951 to 1976 for the state penitentiary wardens and their families to live in. Legend has it that a trustee worked at the house and was locked into the basement at night. (Courtesy of Lynn McNish.)

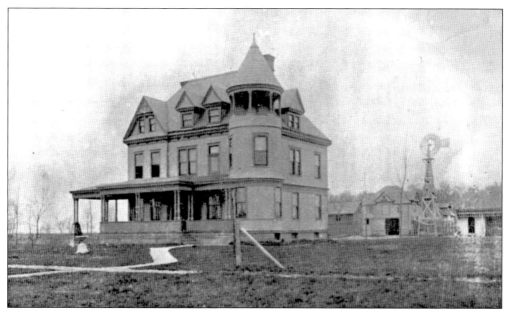

The house at 510 East North Broadway Street, photographed in 1897, was the home of William W. Daniel, an agent for several railroads. Daniel purchased the house in 1896, and it remained in the family until 1961. The one-acre yard had beautiful gardens; the interior was spacious and elegant. By 1966, the mansion became derelict, and it burned down. (Courtesy of Nick Taggart.)

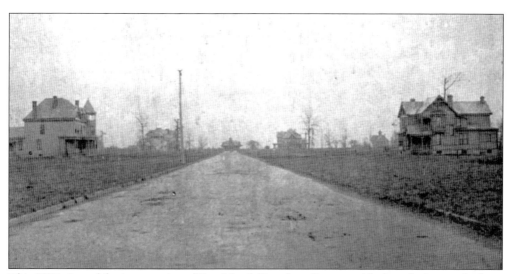

This 1897 view of the intersection of East North Broadway Street and Indianola Avenue looking east shows how undeveloped Clintonville was at the time. The house on the left is the home of Daniel; the house on the right still exists at 489 East North Broadway Street. The North Broadway railroad depot is visible in the distance. Today Interstate 71 is visible. (Courtesy of Nick Taggart.)

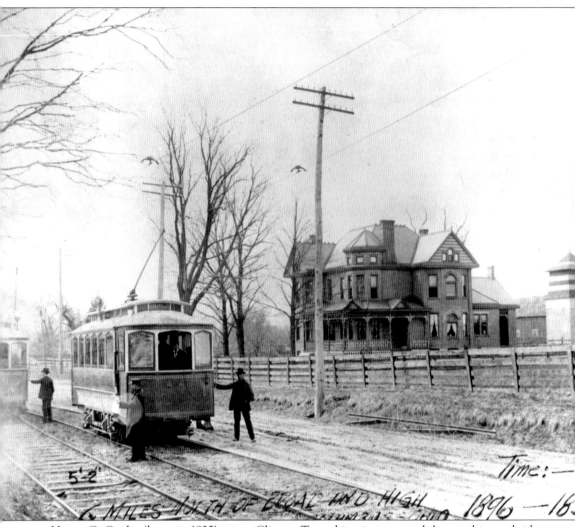

Henry C. Cooke (born in 1825) was a Clinton Township pioneer, stock buyer, shipper, bridge builder, and founder of Cooke, Grant and Cooke general contractors. He owned a 300-acre farm just south Henderson Road and High Street. The area became known as Cooke's Corners, and Cooke Road is named after the family. This magnificent house was owned, around 1900, by Alice Cooke (a descendent of Henry) and her husband, Charles Hess, a great-grandson of Clinton Township pioneer Balser Hess. (Courtesy of Donald A. Kaiser.)

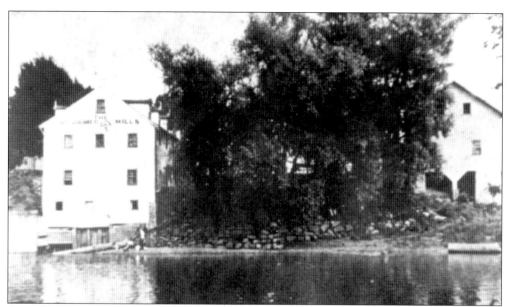

Several generations of mills have existed near what are now Weisheimer Road and the Olentangy River. Seen above is a picture of the last one. The first mill was probably built in 1813 by S. Maynard, purchased in 1837 by Henry Whip, and bought by Jacob Weisheimer in 1865. The grist- and sawmill were powered by a turbine water wheel but destroyed by an ice floe in 1910. Soon afterwards, a new gasoline and electricity-powered mill was erected up from the river. It was torn down in 1955. The house in the picture below was built by the Weisheimer family near the newer mill. The Weisheimer children are standing out front. (Courtesy of the Teater family.)

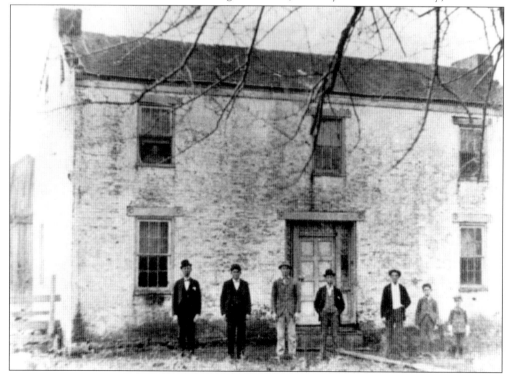

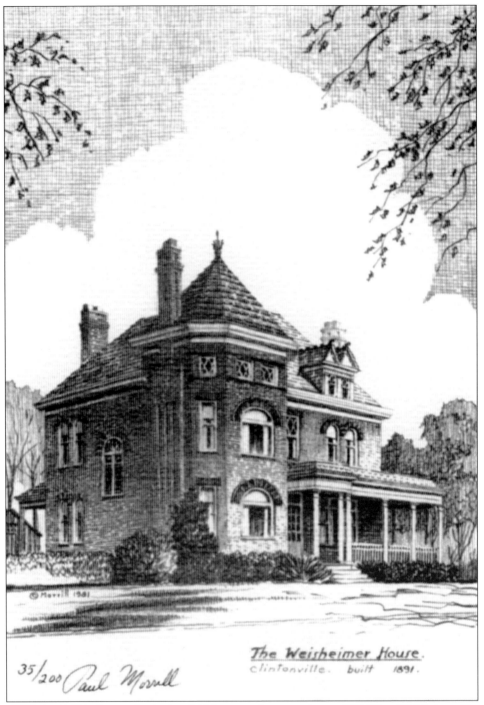

35/200 *Paul Morrill*

The Weisheimer House.
Clintonville. built 1891.

In 1897, Jacob Weisheimer built this 3,406-square-foot mansion at 286 West Weisheimer Road across from the older house. It is listed on the Columbus Register of Historic Properties. The print is one of a series of pen-and-ink drawings of Clintonville landmarks by artist Paul Morrill, commissioned in 1981 by Paul Love on the opening of Love's new real estate office. (Courtesy of Paul Love.)

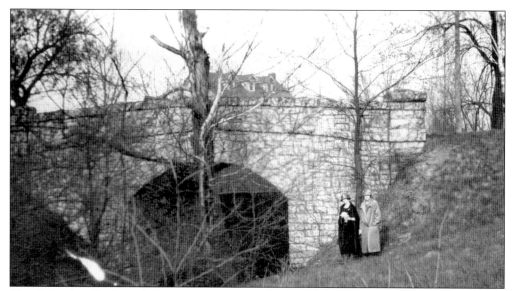

The Columbus Zoological Company incorporated in 1895 and in 1902 purchased 214 acres of land previously owned by the Rathbone and later the Wetmore families. Hit hard by competition from Olentangy and Indianola Parks, the zoo lasted only from June 1904 to October 1905. Some of the land was platted as the Zooland addition in 1905. The remaining zoo property, which is now called old Beechwold, was bought by R. Grosvenor Hutchins and soon after sold to Joseph A. Jeffrey, founder of the Jeffrey Manufacturing Company. Some structures thought to survive from the zoo days are the stone bridge on Rustic Bridge Road and an old barn that housed animals. Some of the land formations are said to be swan lakes and bear pits. Pictured above are Pearl McCann (left) and Jessie Ingalls. (Above, courtesy of Verna Rogers; below, courtesy of Terry Miller.)

Joseph A. Jeffrey used the former zoo property as his summer abode, and his wife named it Beechwalde, meaning beech forest. Jeffrey owned two houses in succession; the photograph above shows the first Jeffrey house, which either burned down or was demolished. The photograph below shows the second Jeffrey house, which is still located at 150 West Beechwold Boulevard, in 1968. (Above, courtesy of W. Henry Hauser Jr. and Sue Milligan; below, courtesy of Sue Milligan.)

In 1906, Charles F. Johnson (1879–1975) teamed with King and Ben Thompson to develop land on the north side of the Ohio State University between High Street and Indianola Avenue, and then they developed Oakland Park, Kenworth Road, Webster Park, and even High Street. In 1914, Johnson went on to develop Beechwold and eventually the Rosemary addition. In total, Johnson developed 97 subdivisions across Columbus. (Courtesy of W. Henry Hauser Jr.)

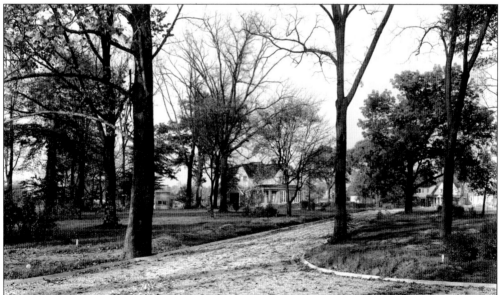

In 1914, Jeffrey sold his Beechwalde land to real estate developer Charles F. Johnson, who platted it, changed the spelling to Beechwold, convinced the city to run water and sewer lines to it, built the first house on each street, and sold lots for $1,300. South of the ravine on Riverview Park Drive, the Beechwold housing development offered tennis courts, a playground, and an apple orchard. This photograph shows how pastoral the land was as the first houses were being developed. (Courtesy of W. Henry Hauser Jr.)

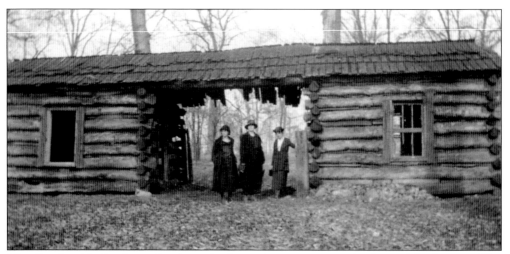

The Beechwalde land was lovely; it had woods, a ravine, orchards, and hedgerows. The photograph above shows, from left to right, Mabel Westervelt, Ora Case, and Helen Westervelt in 1920 at a log structure located somewhere in the area of the Jeffrey summer home. The cabin survived well into the subdivision's development. The 1914 picture below shows a spillway and the rustic bridge. (Above, courtesy of Amy Westervelt; below, courtesy of W. Henry Hauser Jr.)

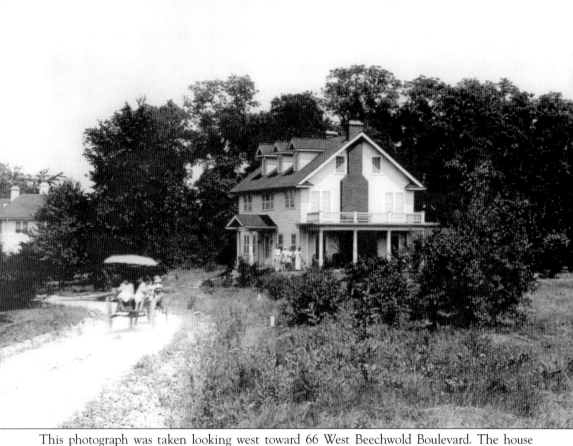

This photograph was taken looking west toward 66 West Beechwold Boulevard. The house was owned by William and Lola Stephens at the time, and so perhaps this shows the Stephens family alongside their house. Old Beechwold is recognized as a historic district on the National Register of Historic Places as well as on the Columbus Register of Historic Properties. (Courtesy of Paul Buster.)

In 1937, Olentangy Amusement Park, located in southern Clintonville, closed, and L. L. LeVeque Company purchased the land, razed the old park, and built an apartment complex. Its architecture was Georgian Colonial, and the centerpiece building was a replica of the Williamsburg, Virginia, statehouse. The complex included 402 apartments plus tennis courts, a swimming pool (a remnant of the amusement park), and picnic grounds. The complex was flanked by a matching commercial center that had a Kroger grocery, Fenton Cleaners, Village Tavern (a Chinese and American restaurant), a bowling center, and a Standard Oil station. (Courtesy of Olentangy Village.)

Two

SACRED SPACES

The oldest institutions in Clintonville are its churches, and the oldest building in Clintonville is a church.

In 1819, eight years after Clinton Township was created, a group of Methodists began meeting in the log home of Eber Wilson. Later meetings were held in the large brick house of Thomas Bull on the east side of High Street between Dunedin and Piedmont Roads. When Bull died in 1823, he bequeathed land to the Methodist Episcopal Church for a chapel, and between 1838 and 1842, the congregation erected Clinton Chapel at the corner of what is now Walhalla Road and High Street. The chapel still stands, although it has been incorporated into the building of the Southwick-Good and Fortkamp Funeral Chapel.

In 1882, friction developed within the Clintonville Methodist Church congregation when they decided to move the church south to a schoolhouse in North Columbus. Those who favored the move believed that the church would serve a larger community in North Columbus, and the church's name was accordingly changed to North Columbus Methodist Church. Part of the original congregation withdrew and formed the Como Methodist Church, which was formally organized around 1905.

Around the same time, North Broadway Street was being developed as an elegant residential area. The developer, James M. Loren, provided a wooded lot for an Episcopal church. As this chapter shows, the first quarter of the 1900s brought Clintonville both explosive population growth and more churches of a variety of Christian denominations. The growth of church buildings was not matched until after World War II.

This is what Clinton Chapel looked like in the 1800s. The Bull family were abolitionists and ran a station of the Underground Railroad within the chapel. The Greek Revival–style building continued as a church until 1881. In 1882, it became a residence for Mathias Armbruster (see page 16). In the early 1900s, graves in the cemetery behind the chapel were reinterred across the river in Union Cemetery. (Courtesy of Southwick-Good and Fortkamp Funeral Chapel.)

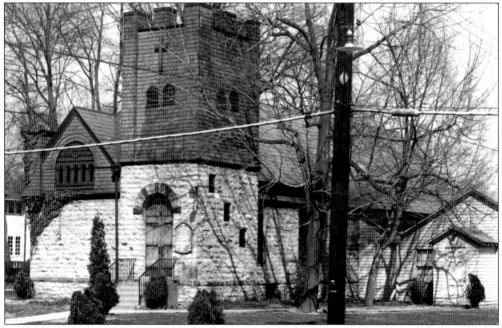

St. James-in-the-Woods Episcopal Mission began in 1881 with a group of worshipers who met in a school and in a room owned by James M. Loren at 215 East North Broadway Street. Loren donated heavily wooded land on Beech Hill Avenue (now called Calumet Street) for a church in 1893, and the building was completed in 1896. It has been modified and expanded several times. (Courtesy of St. James Episcopal Church.)

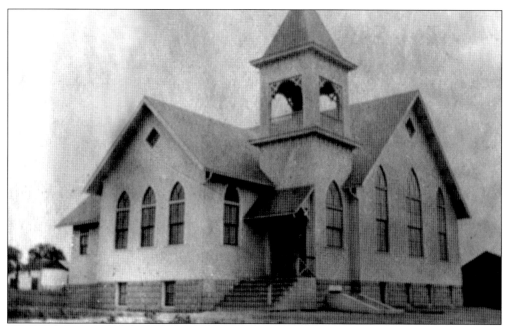

In 1905, Rev. Howard Westervelt organized a Sunday school to serve the Methodist needs of the nascent neighborhood around Como Avenue. The Sunday school met in rooms at the old Clinton school and prayer meetings were held in a home on West Lakeview Avenue. By 1910, the church needed larger quarters, and the Como Avenue Methodist Episcopal Church building was erected at 37 East Como Avenue. This building was enlarged at least once, but the congregation again outgrew its home. In 1924, they built a new church at the corner of East North Broadway Street and Broadway Place and became North Broadway Methodist Church. The North Broadway church's architect was the firm of Martin, Orr, Martin. The Como church structure has continued to host various congregations since, and the North Broadway church has been expanded at least two times. (Courtesy of North Broadway Methodist Church.)

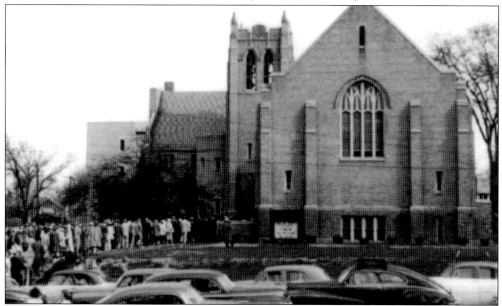

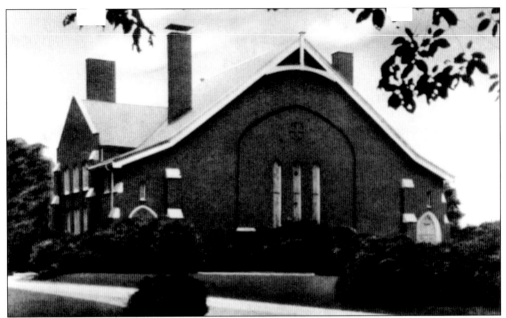

Oakland Park Presbyterian Church purchased land at the corner of Oakland Park Avenue and Broadway Place in 1913 and met in a small metal church. The "tin church" burned, however, and a brick church (shown here) was built between 1919 and 1925. By 1950, the church outgrew this building and built a new church at Croswell Road and High Street, becoming Overbrook Presbyterian Church. (Courtesy of Overbrook Presbyterian Church.)

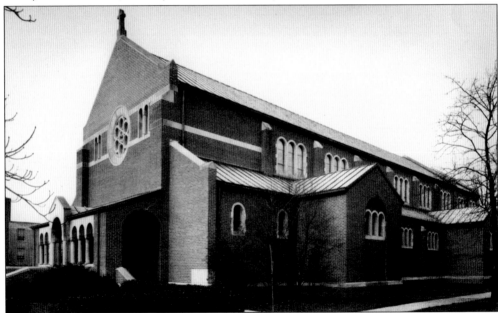

The Immaculate Conception parish was established at 414 East North Broadway Street in 1915, and the church built its first building, a small wooden-frame structure, the following year (see page 91). The church built a school first in 1925, and church services were held there until 1939 when a new church building, shown here in 1948, was dedicated. (Courtesy of Immaculate Conception Church.)

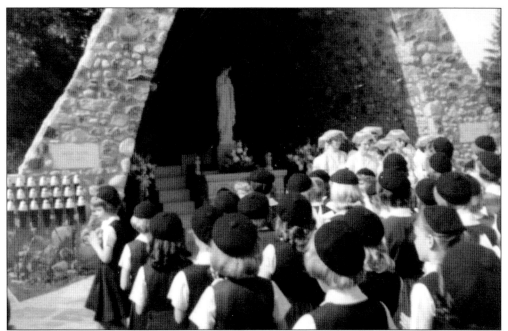

Immaculate Conception Church's grotto was built in 1961. The stones for its construction—granite, marble, iron ore, obsidian, rose quartz, limestone, and coal—were collected by parishioners and came from every state in the union, several nations, and Columbus. Local artist Paul Morrill drew up the plans for the grotto. (Courtesy of Immaculate Conception Church.)

The photograph shows an Immaculate Conception First Holy Communion procession in the 1970s. First communion is one of the biggest days in the religious lives of Catholic children. (Courtesy of Immaculate Conception Church.)

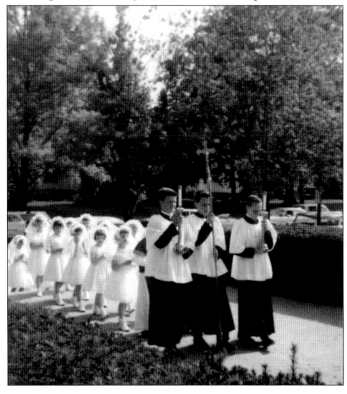

In 1842, Clinton Township School District No. 1 acquired land at Henderson Road and High Street and in 1878 built a brick school building on the southwest corner. The building was used both as a school and for worship services by various denominations. In 1920, the district deeded the school to the Methodist church, and the Maple Grove Methodist Episcopal Church was organized. At the time, it was the only church between Clintonville and Worthington. (Courtesy of the Ohsner family.)

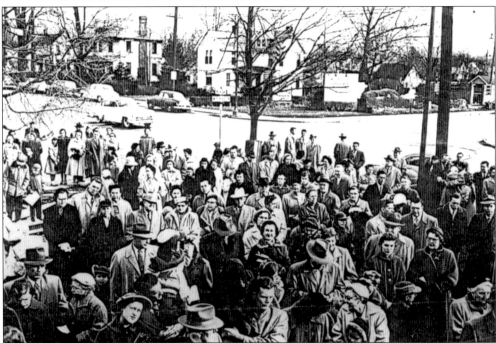

The Maple Grove congregation met in the old hall until 1941. On December 7, 1941, as the parishioners the church were celebrating the laying of a cornerstone for a new church building, they received news of the bombing of Pearl Harbor. (Courtesy of the Ohsner family.)

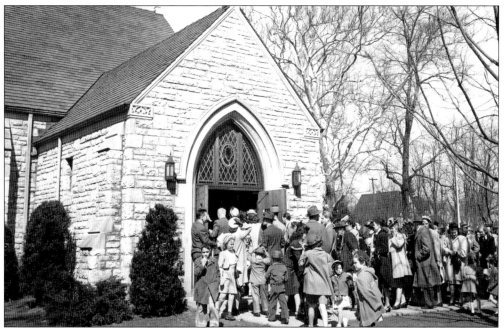

During construction, the congregation met at the Beechwold Theatre, and the church was completed in 1942. The parish hall continued to be used by the church and also by the Columbus school system until Indian Springs School was built. It was razed in 1950. (Courtesy of Maple Grove Church.)

Clinton Heights Lutheran Church organized in 1921 and met at Clinton High School. In 1922, a white frame mission-style chapel was built on the corner of Clinton Heights Avenue and High Street. The church grew steadily; in 1949, a new brick church was built around the old frame edifice, and the house next door (later razed) was acquired for classes. In 1958, the church again expanded. (Courtesy of Clinton Heights Lutheran Church.)

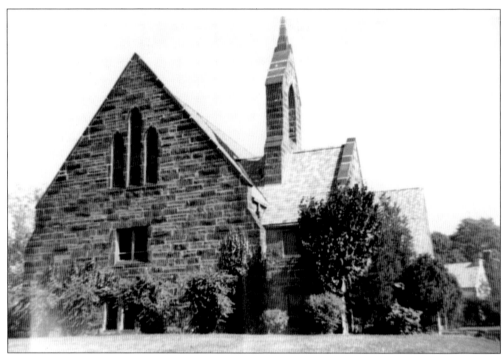

Glen Echo United Presbyterian Church was organized in May 1918. Its first location was the corner of Hudson Street and Indianola Avenue, and the present building at 220 Cliffside Drive was built in 1930. In 1940, a conflict within the church prompted half its members to withdraw and form their own independent church. (Courtesy of Glen Echo Church.)

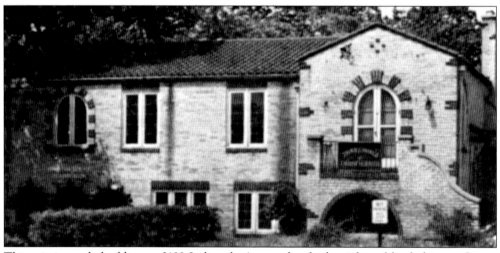

This mission-style building at 3199 Indianola Avenue has had a rich and lively history. It was built in 1926 and is believed to have served as a dime-a-dance place, perhaps a speakeasy. It has served as a synagogue for Congregation Beth Tikva; as Bible Presbyterian Church of Columbus; as Trinity Presbyterian Church; as Church of Christ, Scientist; and as St. Anne's Anglican Church. It is currently a photography studio. (Courtesy of Clintonville Historical Society.)

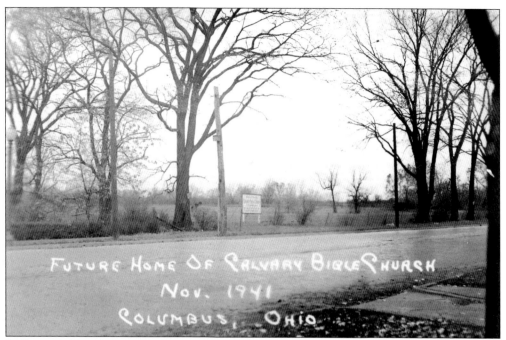

FUTURE HOME OF CALVARY BIBLE CHURCH
NOV. 1941
COLUMBUS, OHIO

William Ashbrook, pastor of Glen Echo Presbyterian Church, resigned in 1940 and, with 114 former members, founded an independent nonsectarian church. The new congregation met at Medary Elementary School until it built its own church. In 1941, the congregation purchased the southeast corner of the old Fuller farm at 3865 North High Street (shown above), and eight years later erected a basement and ground-floor meeting space. The new church was significantly expanded in 1954 and again in 1958. The buff-colored brick building was intended to look like Noah's Ark. Remaining Fuller farmland subsequently became Church of Christ, Scientist; Whetstone Park; Whetstone Recreation Center; the Clintonville Woman's Club; and the Whetstone Library. (Courtesy of Calvary Bible Church.)

Need for a church in northern Columbus inspired a group of Christian Scientists to organize a Christian Science Society. They met at Clinton Elementary School from 1939 until 1942. In 1942, the society moved to 3199 Indianola Avenue. That same year, it purchased part of the Fuller horse farm and in 1952 built the current church at 3989 High Street. The photograph was taken in the early 1950s. (Courtesy of Third Church of Christ, Scientist.)

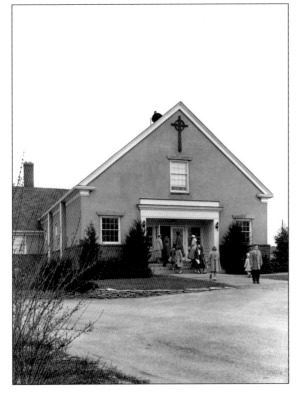

North Community Church's history dates to 1947 when 113 members of Clinton Heights Lutheran Church established a new mission in the growing community of northern Columbus. Their first services were held in the Beechwold Theatre until 1949 when the church acquired three-and-a-half acres on Morse Road and completed the first phase of a three-part building plan. The photograph shows the church shortly after the 1949 construction. (Courtesy of North Community Lutheran Church.)

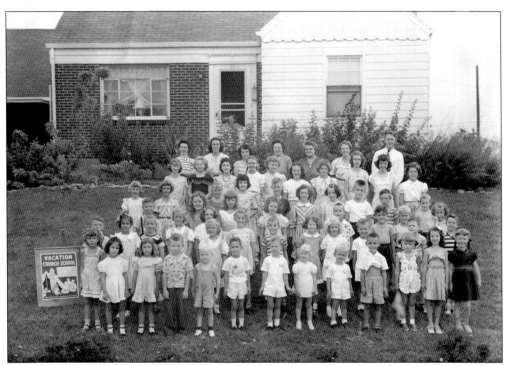

In 1948, a Lenten service was held at 55 West Lincoln Avenue for 10 people who found it difficult to travel downtown to Zion Lutheran Church or to Concordia Lutheran on the far southwest side. Within a short time, the group formed a new congregation and became Worthington Lutheran Church. A sanctuary was built at 35 East Stanton Avenue in 1951, with expansions in 1961 and 1969 and an extensive renovation in 1985. In 1994, the original sanctuary was demolished to make way for a larger new wing. The church was renamed Gethsemane Lutheran Church around 1962 after Columbus annexed the area. The photograph above shows the vacation bible school class of 1949 at the church's original location of 55 West Lincoln Avenue. The photograph below shows the newly-built church in 1951. (Courtesy of Gethsemane Lutheran Church.)

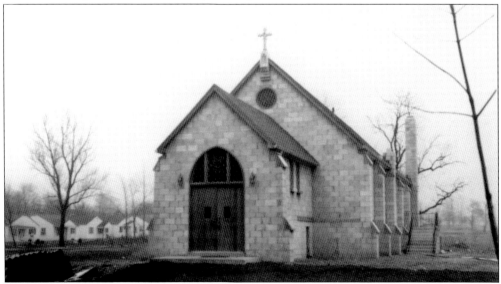

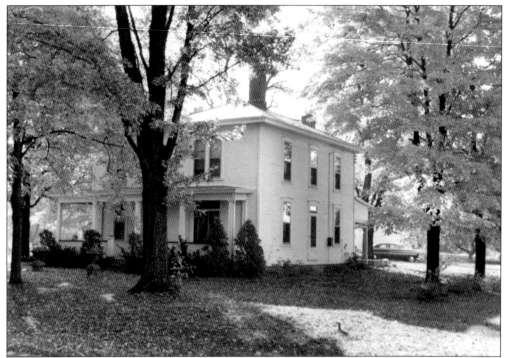

The First Unitarian Church of Columbus began in 1940 and by 1947 was located in the campus area. The congregation purchased the Phillips family (formerly the Stewart family) homestead in Clintonville in 1959 (above) and built a new edifice at 93 West Weisheimer Road in 1961. Shortly after, the Unitarian and Universalist denominations merged. The church building was significantly expanded in 1991 and 1992 and again in 2004. (Courtesy of First Unitarian Universalist Congregation of Columbus.)

Three

THE OPEN ROAD

Essential to Clintonville's story is the road. In 1850, a plank road—dirt fortified with wooden boards—was built by private interests, among them Alonson Bull, Solomon Beers, and John Piatt. The road, built on top of a clay road named the Columbus and Sandusky Turnpike, became known as the Columbus and Worthington Plank Road.

In 1908, motorcars became affordable, and High Street, widened and improved during the 1890s, soon carried more than its share.

Local mass transportation came through Clintonville in three stages: the electric streetcar (trolley), the electric bus (trolley coach, also known as the trackless trolley), and the diesel bus (motor coach). Regional transportation was provided by the interurban railway, which used the same technology as the electric streetcar, and the train. Local transportation was private until 1971, so Clintonville's access to transportation was dependent on the health of the commercial transportation industry.

High Street in Clintonville saw many streetcar-interurban variations over the years. In 1892, a one-mile Columbus and Clintonville Electric Street Railway was built on High Street to connect to the Columbus Consolidated Street Railway at Arcadia Avenue. At about the same time, interests in Worthington built the four-mile Worthington and Columbus Street Railway from Worthington to the north terminal of the new Clintonville line. The two companies feuded over the next few years about division of revenues, to the disadvantage of the customer.

In 1902, the Columbus, Delaware and Marion Railway (CD&M), an interurban line, was started. It took over the two feuding lines, giving the CD&M an entrance into Columbus. In addition to its interurban trains, the CD&M operated a streetcar from Worthington to Arcadia Avenue, where the customers could transfer to another streetcar going downtown. In 1933, the CD&M went out of business, and shortly thereafter the Worthington streetcar service ended. The Columbus Railway Power and Light Company, which had previously extended its streetcar track from Arcadia Avenue to Webster Park Avenue, extended its track and service to Blenheim Road, and motor bus service provided transportation from Blenheim Road to Worthington.

In 1947, Clintonville's electric streetcars were eclipsed by electric buses, which were in turn replaced in 1965 by diesel buses.

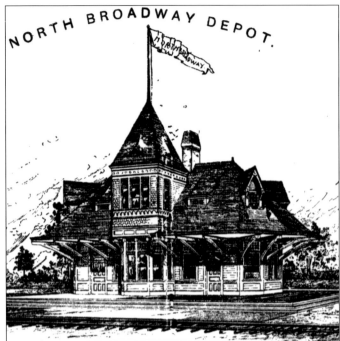

When James M. Loren subdivided North Broadway, he had East North Broadway Street paved with Hallwood block, installed brick sidewalks, and even built a depot at the eastern end of North Broadway Street to ensure that residents had ready access to the railroad. This is a drawing of the North Broadway railroad depot in the mid-1890s. (Courtesy of Gary Means.)

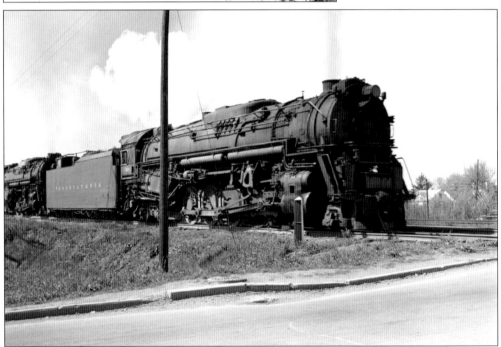

Clintonville's eastern boundary is the railroad tracks paralleling the current Interstate 71. The tracks represent a series of railroad mergers, and their most notable owners were the Cleveland, Cincinnati, Chicago and St. Louis Railway, commonly called the Big Four Railroad, and the Pennsylvania Railroad. The former is now named CSX Transportation, and the latter is Norfolk Southern Railroad. Here a Pennsylvania Railroad coal train travels northbound at Oakland Park in 1953. (Courtesy of Donald A. Kaiser.)

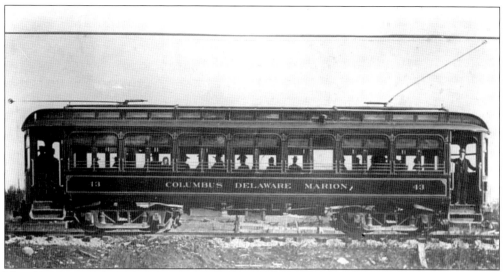

The CD&M traveled north on Summit Street to Arcadia Avenue, west on Arcadia Avenue down a steep hill, then turned north on High Street to Worthington and beyond. It had more comfortable seating and fewer stops than streetcars and was more expensive to ride. Though its location is not known, this 1902 interurban is typical of those traveling High Street. (Courtesy of Alex Campbell.)

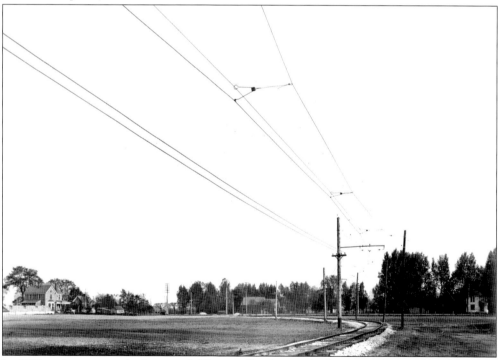

In 1922, a bypass was built around Clintonville that took the interurbans off High Street. The interurbans instead traveled along the northern edge of Glen Echo Ravine to a private right-of-way paralleling the Big Four Railroad tracks to north of Worthington. This is the bypass between Oakland Park Avenue and North Broadway Street around 1923. The overhead electric lines provided power to the cars. (Courtesy of Alex Campbell.)

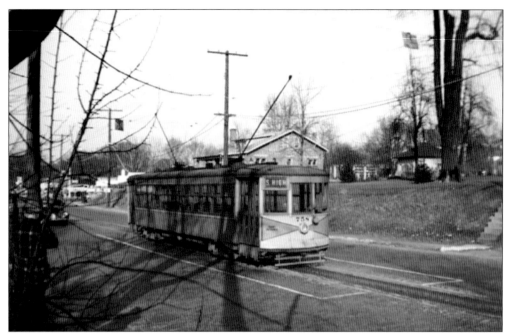

This streetcar was photographed just north of Blenheim Road in 1947 at the end of the streetcar line. The motorman is in the process of preparing for the trip south. Streetcars also ran from downtown up Summit Street, jogged over what is now known as Hudson Street, and went northbound on Indianola Avenue to Oakland Park Avenue. (Courtesy of Alex Campbell.)

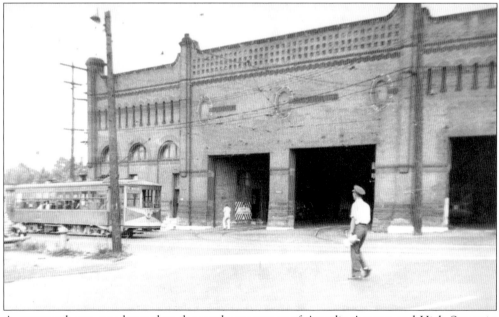

A streetcar house was located at the southeast corner of Arcadia Avenue and High Street in 1887 and used by a succession of street railway companies. In 1951, Columbus Transit Company took over local transportation and sold the site to an automobile dealer who in 1953 razed it to make way for a used-car lot. Today a small section of the building's back wall still stands. (Courtesy of Alex Campbell.)

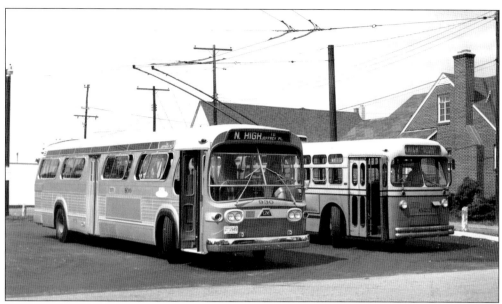

In 1947, the transportation company switched from electric streetcars to electric buses. The buses were powered by overhead wires but did not need tracks, so the system was easier to expand and cheaper to maintain. They required turnaround space, and turnouts were installed at Blenheim Road and Jeffrey Place. The electric buses were used from 1947 until 1965 when they were replaced by diesel buses. Here both types of buses rest at the Jeffrey Place loop. (Courtesy of David Bunge.)

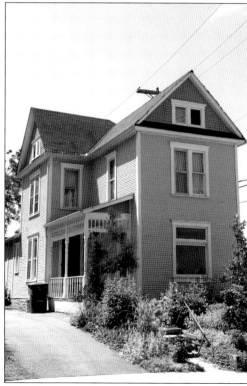

This building, presently located on East Dodridge Street, is believed to have originally served as the tollhouse for the Worthington Plank Road (now known as High Street). The tollgate blocked High Street just north of Arcadia Avenue. At night, travelers had to wake the toll collector and pay him 3¢ per vehicle, whereupon he let them go on their way. (Courtesy of Lynn McNish.)

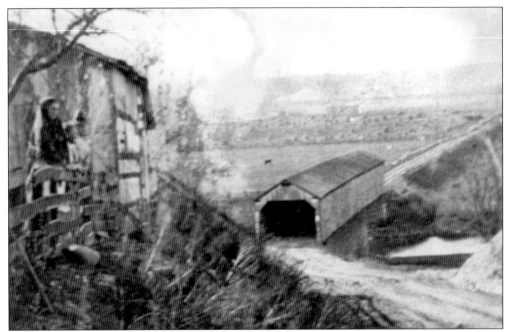

For many years, there were just two local bridges Clintonville residents could use to cross the Olentangy River. Dodridge Bridge, at the southern end of Clintonville, was one of them; the other was at Henderson Road. Taken around 1880, this photograph, looking west from the eastern side of the river, shows Dodridge Bridge was once covered. (Courtesy of Judy Cohen.)

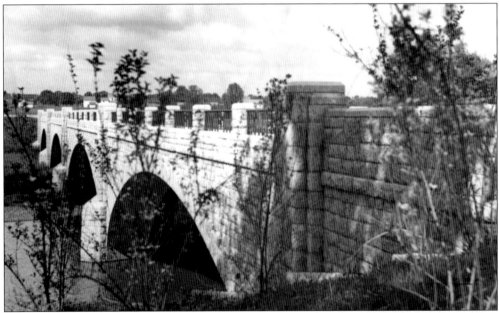

When John R. Dunlap subdivided his land for development in 1893, he dedicated a 100-foot right-of-way along West North Broadway Street for street purposes. This might indicate that he had a bridge in mind; however, it was 46 years before that came to pass. North Broadway's bridge was built in 1939 using Public Works Administration funds. It was a stone-faced reinforced concrete bridge. (Courtesy of Franklin County Engineers.)

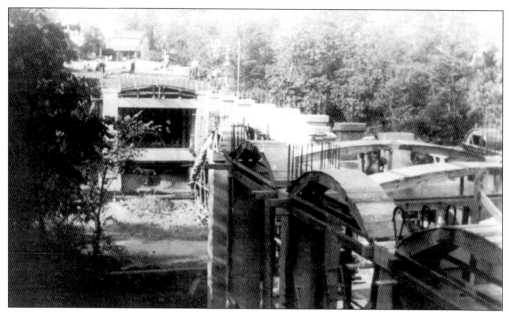

Bridge historians call the 1930s "Ohio's decade of decorative arches." Because of widespread unemployment, a large and skilled labor force was available to the Ohio Bureau of Bridges. Also, demand was growing for aesthetically pleasing public structures. The bureau was staffed by engineers with sensitivity and talent to use these circumstances to advantage. Until 1934, there was no easy means of crossing the Walhalla Ravine. In 1934, a concrete open-spandrel arch bridge was built over the hollow. These photographs show the bridge as it was being erected and the finished bridge. The bridge was removed in 1990, and a new bridge was put in its place. (Above, courtesy of Connie Fletcher; below, courtesy of the Ohio Historic Preservation Office.)

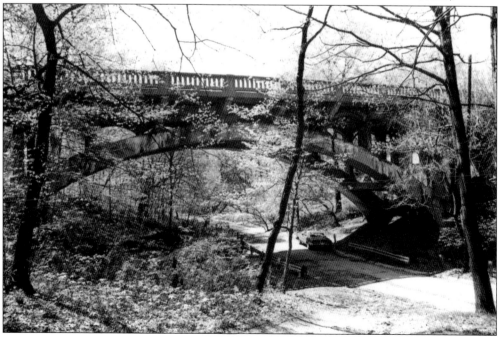

This picture shows Glenmont Avenue looking east toward Indianola Avenue in October 1923 before Glenmont Avenue was paved. The area was still a farming community, and those who built houses there liked it that way. The Glenmont Community Club, a neighborhood association, initially opposed annexation by the city because they wanted to maintain the quiet atmosphere. (Courtesy of Judy Morrison Robinson.)

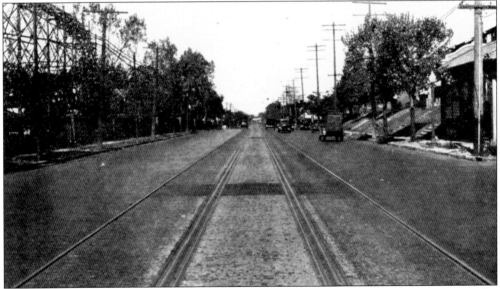

Here is a view of High Street in 1939 with its dual-gauge streetcar tracks, looking north, at Kelso Road. Olentangy Park is visible on the left (west) side of High Street. The park's last season was 1937, so this view was a sad reminder of the park's past glory. (Courtesy of Melissa Goodrich.)

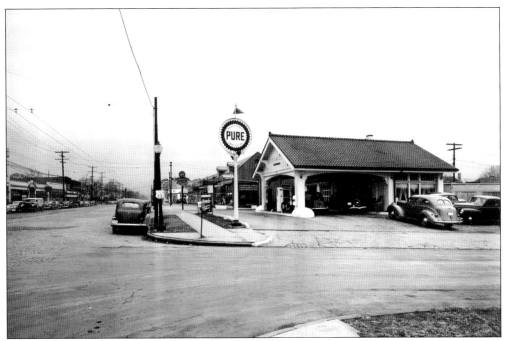

These photographs show High Street near Torrence Road in 1947. In the picture above, notice the Gray's Cut Rate pharmacy and a Sinclair station in the background. The old Pure Oil station in the photograph still stands today but has been put to other uses. The photograph below shows the same intersection looking north from Oakland Park Avenue. The old Kroger and an Albers supermarket are visible on the right (east) side of the street. High Street was paved with brick and had streetcar tracks. (Courtesy of Galen Gonser.)

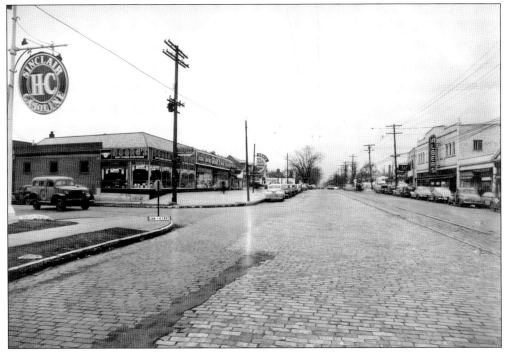

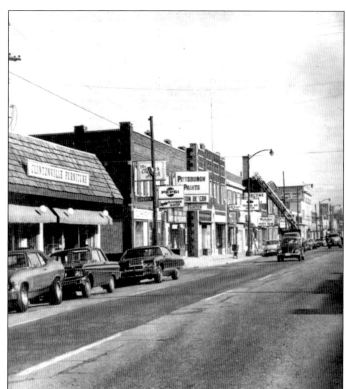

During the mid-1970s, southern Clintonville's portion of High Street was in economic decline, and community leaders worked to strengthen Clintonville's business environment. Note the Longview Barber Shop—perhaps the longest-running business in Clintonville, and a healthy one—which was, at the time, several doors south of its current location. Most of the other businesses along the street in this photograph no longer exist. (Courtesy of Longview Barber Shop.)

In 1926, fourth grader John Condon dashed across High Street to return to Clinton Elementary School and was hit by a streetcar. Condon lived but lost his leg. Fred Postle, a city councilman and neighbor, proposed that the city construct a pedestrian subway connecting Brighton Road to Clinton Heights Avenue. Students still use the subway. Pictured is Postle's daughter Freda Koch standing alongside the tunnel in the 1970s. (Courtesy of the Robert Koch family.)

Four

WORK AND COMMERCE

The city of Worthington was established in 1803, and the city of Columbus was founded in 1812. Between those two towns along the Worthington Plank Road mail route arose Clintonville, a tiny, unplatted business district centered on the corner of Orchard Lane and High Street.

Columbus expanded northward, and the businesses serving Worthington expanded southward. Meanwhile, various intersections along High Street—Arcadia Avenue, Orchard Lane, Henderson Road, Weisheimer Road, Charleston Avenue—developed their own sense of neighborhood, with their own business communities, motivated by their proximity to important streetcar stops, by their need for natural resources, or by their distance from other communities. Gradually, real estate developers filled in the spaces between these areas, fueling additional commercial development.

Even though Clintonville's commercial districts are found along two parallel north–south routes, the growth of the business community has never been linear time wise. Businesses have blossomed along High Street and Indianola Avenue, servicing those traveling along the Worthington Plank Road since the beginning of its existence.

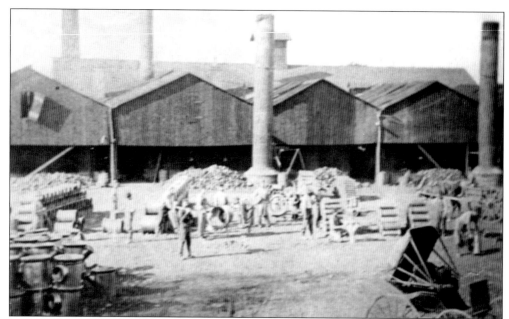

In the early part of the 20th century, several brick and tile companies were located along Arcadia Avenue east of High Street. They collected clay from Glen Echo Ravine and made sewer pipes used throughout the city and bricks that paved Clintonville roads. This was Clintonville's only heavy industry. This photograph shows the Columbus Sewer Works in 1880. In 1924, the location became North High School. (Courtesy of Judy Cohen.)

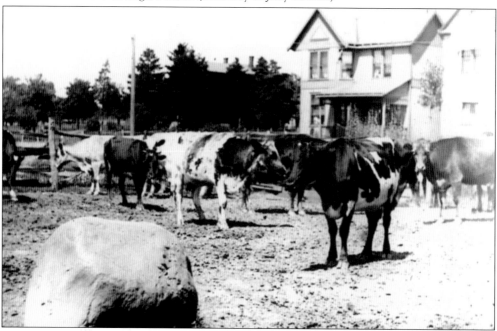

It is sometimes hard to believe that Clintonville was once an agrarian community. Here is proof. Some sources say this is the Kimball and Grove Dairy, and others say it is the Wilcox and Gay Dairy. It was located northwest of Pacemont Road and High Street in 1904. (Courtesy of The Columbus Dispatch.)

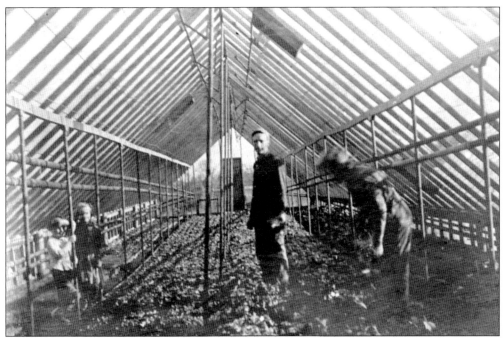

This 1910 greenhouse was on West Como Avenue. Alanson Westervelt and his family grew lettuce and a few other truck-farming products near their home on the south side of West Como Avenue. Shown from left to right are Mabel Westervelt, Frank Westervelt, their father, Alanson Westervelt, and a hired worker identified only as Henry. (Courtesy of Amy Westervelt.)

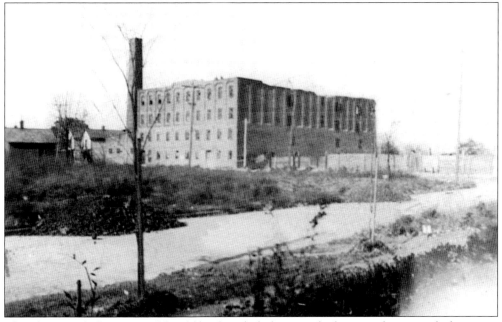

This photograph shows one of the old brick and tile factories, looking northeast, just before it was torn down in 1923 to make way for a new North High School building. The tile companies were serviced by a railroad spur that ran from the Big Four Railroad track to the factory. (Courtesy of Leeann Faust.)

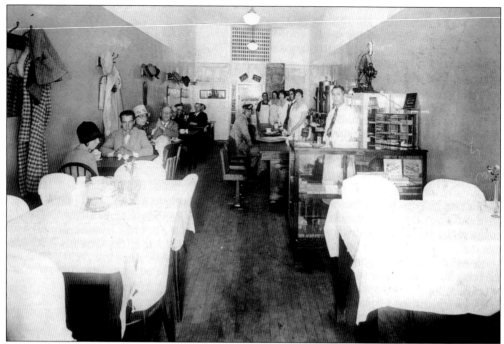

In 1928, Theodore's Lunch was a restaurant located at 3514 High Street just north of Oakland Park Avenue. Proprietor Theodore Stefanovich lived at 17 West North Broadway Street. Like most owners, he employed relatives to help out at the restaurant. Workers from left to right are Kostandina, Anna, Angeline, Peter, Vasileka, and Theodore Stefanovich. (Courtesy of John Elech.)

One of Clintonville's pioneer families, the Whips owned a farm and operated several fruit stands, selling refreshing fruit drinks at each. This 1929 advertisement promoted the stand located at the southeast corner of Weisheimer Road and High Street. Whip ancestors were the original owners of the mill that came to be called Weisheimer Mill. (Courtesy of Suzanne Gallogly.)

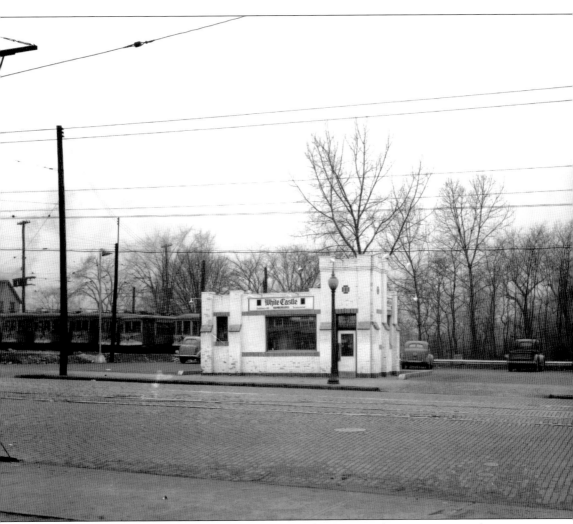

The White Castle opened in 1929 at the foot of Arcadia Avenue—by no mean coincidence near North High School. Styled of glazed brick after Chicago's historic Water Tower, it was one of the first six White Castles in Columbus. Trolley cars were stored just south of the Clintonville White Castle. In 1951, "building number 4" was replaced with a porcelain-enamel facility. In 1986, that structure was removed to Harrisburg, Ohio, and replaced with an even newer facility. (Courtesy of Jim Caronis.)

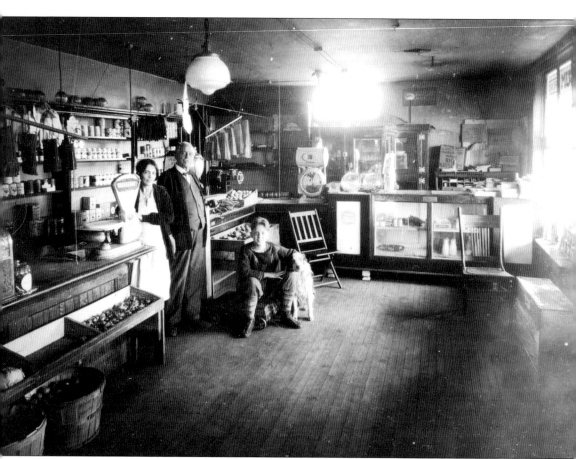

This market on High Street between Chase Road and Lincoln Avenue was named Stop 18. It was likely located within the interurban car stop of the same name. Vivian Clark stands alongside her father and her son Bob. Her father set up Clark, a single mother, with the store to assist her financially. The store lasted a few years and was probably driven out of business by the Great Depression or the 1933 closure of the Columbus, Delaware and Marion Interurban railway. A year after the interurban went out of business, the building was purchased and made into a rather infamous tavern and then was demolished in 1968. (Courtesy of Gladys Simoni.)

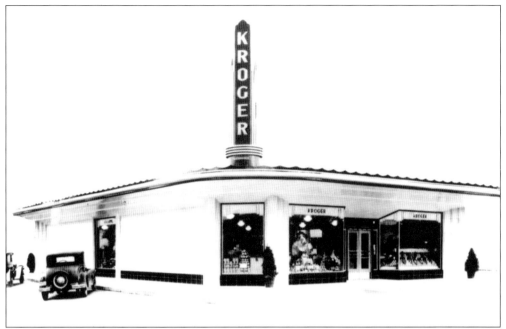

This Kroger market was at 3550 High Street from about 1934 to the early 1950s. It was touted as being the "first drive-up grocery store in the city of Columbus," which meant that it provided parking for cars. The modernistic building is now occupied by Cover-to-Cover Books. (Courtesy of Casto Corporation.)

Clintonville seemed to have a bakery and a drugstore on every block. The northwest corner of Como Avenue and High Street has been a bakery since 1925. This photograph shows Charles Ferris (right) and an unidentified coworker at Como Bakery in the 1930s. It later became Clintonville Bakery (see page 60) and, around 1978, Whole World Pizza and Bakery. By the 1960s, most other bakeries were eclipsed by chain grocery stores with in-store baking departments. (Courtesy of Amy Westervelt.)

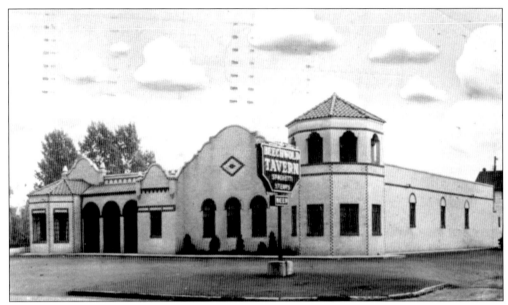

In 1934, the Delewese family opened the Beechwold Tavern at 4784 High Street, shown here in 1936. Henri Boyd took over the mission-style building in 1938, and the Beechwold Restaurant came into being. From 1965 to 1967, it was the Golden Bull Restaurant and then a media studio, a rug store, and is presently a camera shop. (Courtesy of Melissa Goodrich.)

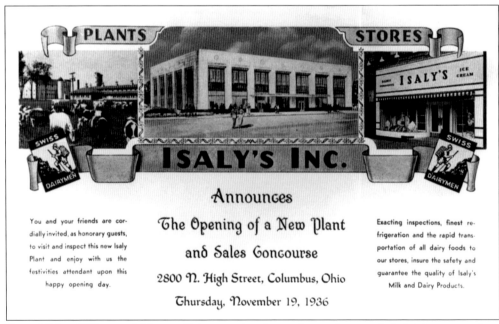

PLANTS **STORES**

ISALY'S INC.

Announces

The Opening of a New Plant and Sales Concourse

2800 N. High Street, Columbus, Ohio

Thursday, November 19, 1936

You and your friends are cordially invited, as honorary guests, to visit and inspect this new Isaly Plant and enjoy with us the festivities attendant upon this happy opening day.

Exacting inspections, finest refrigeration and the rapid transportation of all dairy foods to our stores, insure the safety and guarantee the quality of Isaly's Milk and Dairy Products.

From 1936 to 1953, one of Clintonville's crown jewels was the art deco–style Isaly's ice cream plant at 2800 High Street. The plant produced ice cream for the whole Columbus area. After the plant closed, the building became headquarters for Beverlee Drive In but was demolished around 1966. (From *Klondikes, Chipped Ham, and Skyscraper Cones: The Story of Isaly's,* by Brian Butko.)

This structure at 3415 Milton Avenue was built around 1900. Miles Elmers purchased it around 1935. There he started Agricultural Laboratory Incorporated, a manufacturing center, laboratory, and office. Elmers was packaging a product called Sterox for Monsanto, and when Monsanto decided to discontinue the product, Elmers bought the formula, reconstituted it, repackaged it, changed its name to All, and the legendary laundry detergent was born. (Courtesy of Lynn McNish.)

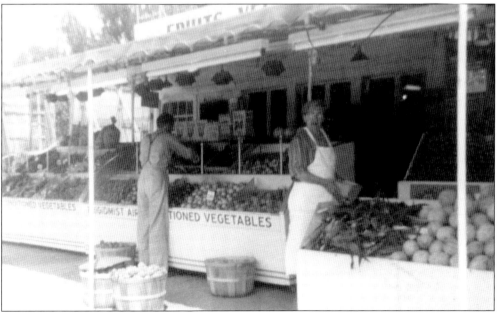

The Lynd family has owned orchards near Pataskala and New Albany since 1918. Two Lynd brothers, William Kermit and John Kenneth, opened Lynd's Farm Market at 4084 High Street in 1946 but sold the enterprise in 1953 to manage one of the family markets closer to home. This photograph shows Lynd's Glenmont market on September 10, 1946. (Courtesy of the Kerchner family.)

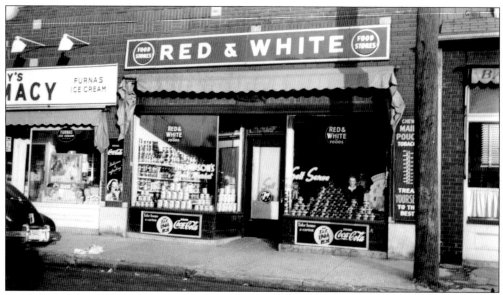

In 1946, Ralph and Olive Thompson opened this Red and White Grocery at 3366 Indianola Avenue, between Oakland Park Avenue and North Broadway Street. The grocery remained open until about 1950. The pharmacy next door is Brody's Pharmacy. The building was probably razed in 1971 to make way for Huntington Bank. (Courtesy of Linda Thompson.)

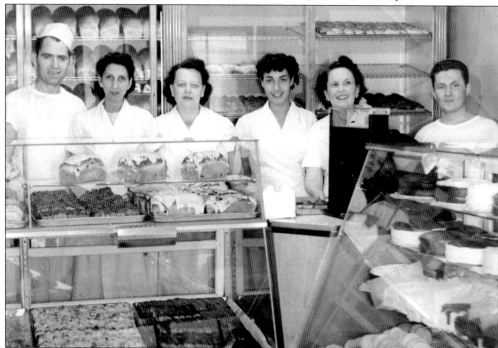

This 1948 bakery was owned by Theodore Elech, who was married to Angeline Stefanovich, the daughter of Theodore Stefanovich (see page 54). The bakery was located at 3129 High Street near California Avenue. In 1951, he moved his bakery business to 3269 High Street, renaming the location Clintonville Bakery. He owned it until 1978. Shown from left to right are Theodore, Angeline, Dorothy ?, Marietta Petsef, unidentified, and unidentified. (Courtesy of John Elech.)

Virginia Walcutt Gay wanted to provide for retired teachers by giving them a retirement residence at a reasonable cost. She established the Virginia Gay Home for Aged Women through her will. After her death in 1914, the will was contested by her nieces. The case dragged through the courts, significantly diminishing funds for the home. The home finally opened in 1932 with 15 women whose care was endowed by the home, and the nieces were purportedly banned from the premises. The Methodist Retirement Center of Central Ohio acquired the property in 1965 and adopted the name Wesley Glen for a new retirement community. The original building still exists but is somewhat overshadowed by newer structures. (Courtesy of Wesley Glen Archives.)

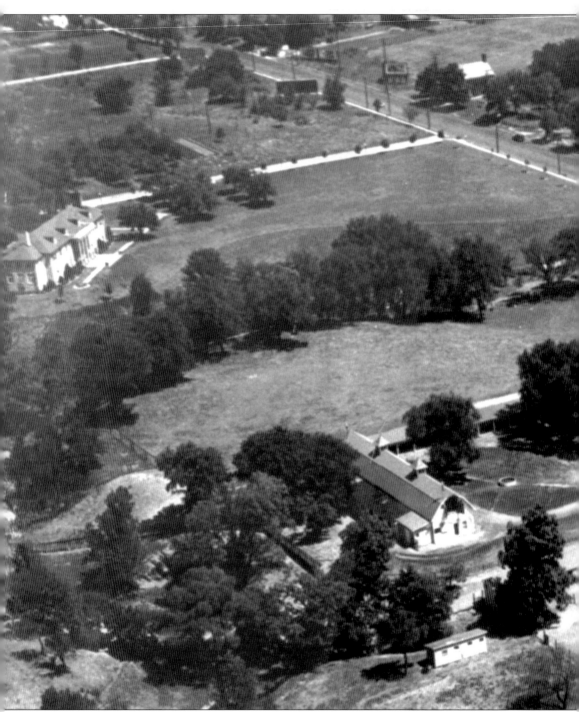

Maurice Patrick Murnan (1866–1937) initially worked on the railroad. It is said that, en route to his job, he ventured into a gambling house and with phenomenal luck won the gambling establishment from its owner. His new business grew, and Murnan became wealthy. In time, he purchased the 700-acre farm of R. Grosvenor Hutchins, a member by marriage of the Jeffrey family. On the farm at 5058 High Street, Murnan established a horse farm called Murnan Farms

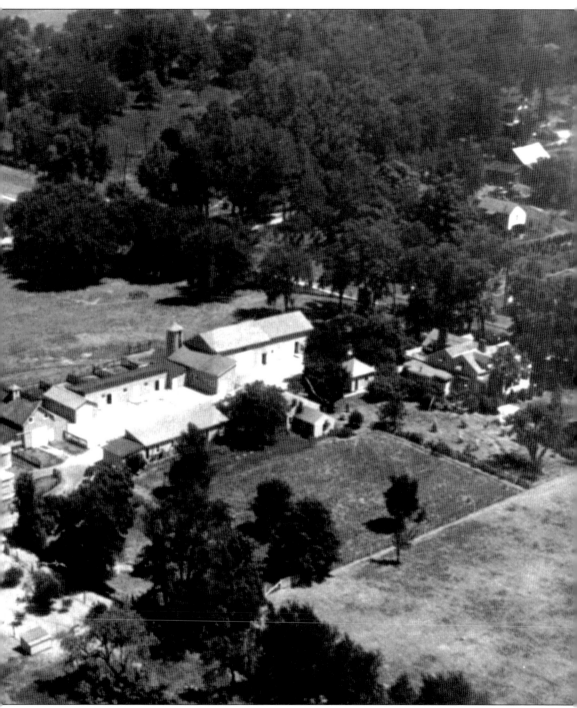

(also known as Graceland Stock Farm). During the Depression, the northern portion of the land was sold to the Virginia Gay Trust, visible on the left of this image taken around 1933. High Street is the diagonal road running from the upper-left corner. The large, low building at the right is Murnan's house, and his farm lies westward from High Street. (Courtesy of Clintonville Historical Society.)

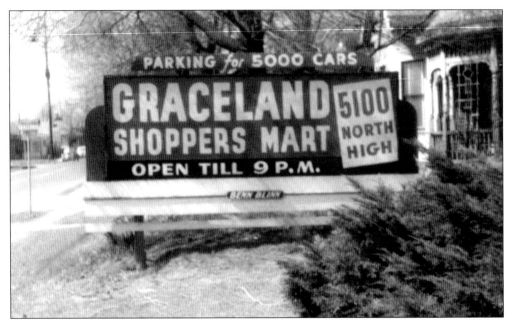

Grace Backenstoe, a madam of a well-established downtown sporting house, lived with Maurice Patrick Murnan at the farm. When he died in 1937, Backenstoe expected to inherit everything but died in 1939 before the estate was settled. In 1946, the property was sold at auction to the Roman Catholic diocese. In 1952, investors purchased it, and Graceland Shoppers Mart was developed by Don Casto, who had played there as a youth. (Courtesy of Casto Corporation.)

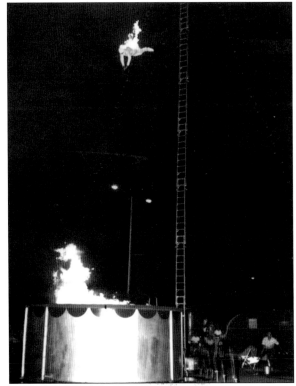

Grandma Carver was a high-dive artist who plummeted more than 90 feet into a five-foot water tank topped with flaming oil. She performed at many of Casto Corporation's shopping centers, especially at grand openings, in the 1950s. She performed at Graceland from July 29 to August 3, 1957, for $250. (Courtesy of Casto Corporation.)

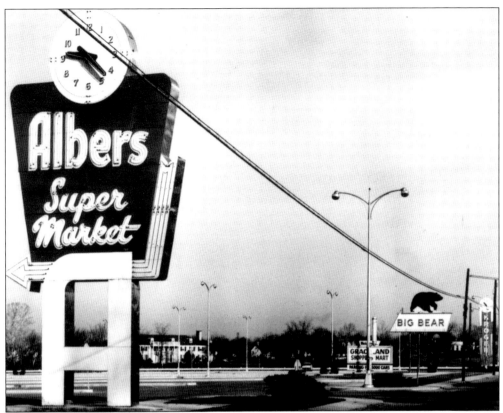

Graceland mall originally included a theater, miniature golf course, three grocery stores, a hardware store, J. C. Penney, Walgreens, and plans for a total of 100 stores. For Clintonville, it marked the beginning of the decline of the independently owned and operated retailer. Independent businesses that survived differentiated themselves through quality service yet continue to face a herculean challenge. Note the Virginia Gay Home for Aged Women visible in the background. (Courtesy of Casto Corporation.)

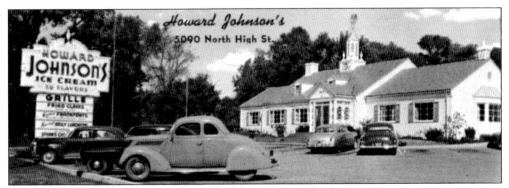

This Howard Johnson's restaurant was located at 5090 High Street across from Graceland. Howard Johnson's was one of the most recognizable icons of American culture in the 1940s, 1950s and 1960s, as easy to identify as McDonald's golden arches are today. Howard Johnson's typified the trend toward national chain restaurants. Families knew exactly what they would encounter, yet the ubiquity of chains soon divested neighborhoods of local color. (Courtesy of Melissa Goodrich.)

Gatto's Pizza may be the longest running family-owned food business in Clintonville. Jimmy Gatto started the restaurant at 2928 High Street in 1952. His brother Joe joined him in the business in 1955, and Gatto's Pizza has been serving Clintonville continuously since. Joe's sons Joe Gatto II and Vince Gatto and their cousin Bill Fulcher purchased the restaurant in 1981. The photograph shows Jimmy, Joe, and their brother Jerry Gatto in the late 1930s. (Courtesy of Vince Gatto.)

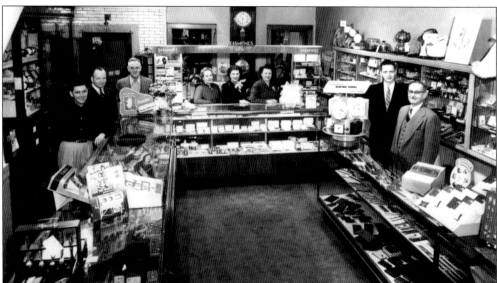

Homer W. Miller and Son Jewelers was reputed to have put more rings on Clintonville couples than all other jewelers combined. In 1919, Miller opened his store near 2650 North High Street. With an eighth-grade education, he supported family and staff and met his financial obligations through the Depression. In 1934, he moved to 2595 High Street and remained there until 1988. His son Gordon joined him in 1953. Homer is on the right and Gordon is second from the right in this 1953 photograph. In 2002, Gordon retired and the business closed after serving three generations. (Courtesy of Gordon T. Miller.)

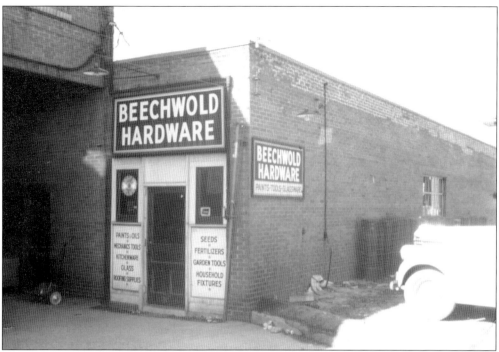

Beechwold Hardware was begun in 1944 by Forrest Smith in a small former automobile repair garage. Nine years later, his son Jack Smith joined the business. The business has remained family owned since its start. This photograph shows the original small store, which is still used by Beechwold Hardware. The building immediately to the south was originally Schob's, later Cole's, and eventually Knight's Pharmacies. Beechwold Hardware expanded its business into the south building after Knight's Pharmacy closed in 1986. (Above, courtesy of Jack Smith; below, courtesy of Kroger.)

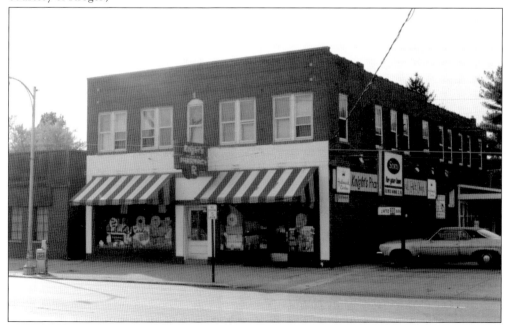

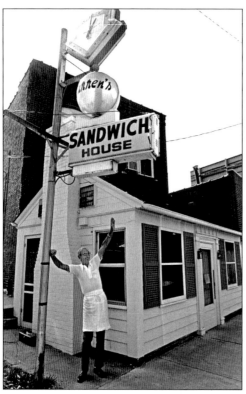

This diminutive location was the Clinton House Restaurant and Bakery from 1939 to 1945. By 1950 or 1951, Warren Gardner (seen here) owned the store, and it was a Columbus classic called Warren's Sandwich House. It had just six stools, was open 24 hours a day, and served delicious grade-A beef hamburgers. It closed around 1983. (Photograph by Jeffrey A. Rycus, © 2008 courtesy of Rycus Associates Photography.)

Children worked too. Here Robert Koch prepares his *Columbus Citizen-Journal* newspapers for delivery in 1955. Carriers, aged 10 to 15, assembled and delivered their newspapers daily and then collected money from subscribers on Thursdays. In the 1950s, they probably earned $8 for a 16-hour workweek. Major newspapers declined to hire girls until the late 1960s, arguing that girls could earn equivalent money by babysitting. (Courtesy of the Robert Koch family.)

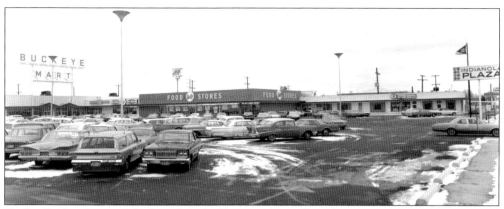

Hadler Realty Company built Indianola Plaza at 3600 Indianola Avenue in 1966. At the time, businesses preferred that their storefronts be given individual appearances. The plaza was anchored by Buckeye Mart, a mass-merchandising department store. Buckeye Mart moved out in 1973 and was replaced with a discount clothier, then a boat store. The space is currently a thrift store. The photograph above shows the plaza in 1967. Weiland's Fine Meats, the present anchor store of Indianola Plaza, opened in 1962 at 4442 Indianola Avenue and moved to the plaza around 2000. The photograph below shows its original sign at that first location. (Above, courtesy of Hadler Realty Company; below, courtesy of Weiland's.)

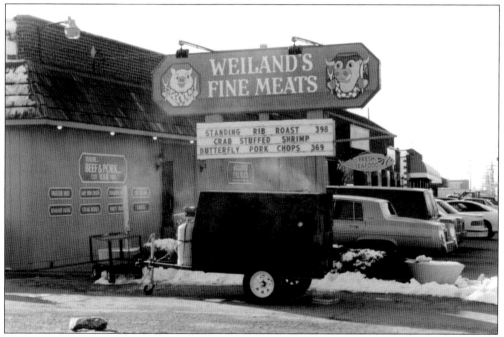

The corner of Crestview Road and Calumet Street has long been commercial. Jan Jay purchased the grocery and a house nearby in 1965 so that her children could attend North High School and then differentiated the business by becoming the first Asian food store in Columbus. The Asian business was subsequently sold, and the building then served as a Christian reading room. In 1996, it became Clintonville Community Market. (Courtesy of Jan Jay.)

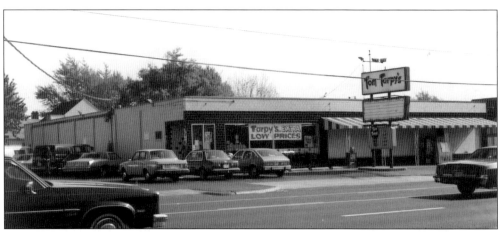

Clintonville has been home to many independent grocery stores. The one-story building at 4578 High Street started as a William's Market, then became an IGA store, and in 1973 became Tarpy's Market. With the increase in the number of supermarkets and convenience stores, most of Clintonville's independent grocers closed. Tarpy's Market closed in the mid-1980s. (Courtesy of Kroger.)

This building was at 3493 High Street on the corner of Kenworth Road. Built in 1925, it was a filling station and then Medick Ford from the mid-1930s to World War II. Bob Daniels Buick took over the property in the late 1960s. It had an octagonal tower, conical slate roof, and garage bays. By the time this picture was taken in 1985, the pointed roof had been removed. Note the former Scott house (see page 17) in the background. (Courtesy of Kroger.)

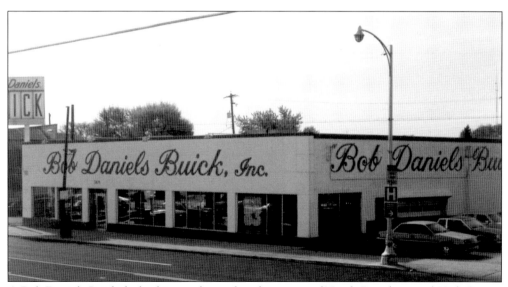

A Bob Daniels Buick dealership was located at the corner of North Broadway and High Streets from 1950 to 1982. The dealership was unable to expand on the corner because of a gas line, and it moved to Morse Road in October 1982. Kroger demolished the dealership and the old Medick Ford building and built a super store on this corner three years later. (Courtesy of Kroger.)

Prior to 1944, drugstores, with their gleaming ice-cream counters, were neighborhood gathering places. After World War II, drugstores replaced their soda fountains with cards, comic books, and gifts. Beechwold Pharmacy, at 4622 High Street, was the last drugstore in Columbus with a soda fountain. When Arden and Pat Engelbach retired in 1997, their soda fountain was sold to Wittich's Candy Shop in Circleville. (Courtesy of Arden and Pat Engelbach.)

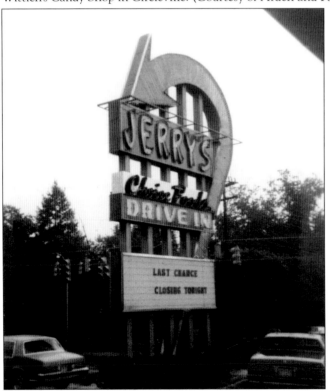

Jerry's Drive In Restaurant was located at 4910 High Street on the corner of Morse Road from 1961 or 1962 to 1986 or 1987. Jerry's was famous for its cream horns and other baked goods. In the 1960s, Jerry's was also the northern end of cruising activity on Friday nights. When it closed, it became a Sister's and in 1992 Tee-Jaye's Country Place. The sign with the huge neon arrow is larger than modern ordinances allow and has been grandfathered under Columbus' code. (Courtesy of Leeann Faust.)

Five

COMMUNITY

Clintonville was never platted as a formal village. Landowner Alonson Bull sold several small lots to tradesmen for their shops. A post office opened in 1847, located in a building near the northwest corner of Orchard Lane, and was given the name Clintonville because it was located at the center of Clinton Township. In 1913, the post office was moved to a grocery store at Dunedin Road and High Street; it operated there until 1917. There were other post offices serving the area now known as Clintonville as well. There was a post office from 1893 to 1902 at the eastern end of North Broadway Street, just north of the railroad depot, and one near the Homedale area during the 1950s.

The local newspaper, the *Booster*, reinforced the emerging community's sense of identity. It provided much-needed advertising for businesses, gave its readership local news, rallied residents over issues of importance, and sponsored community picnics.

As early as 1937, businesspeople of the area convened various organizations, such as the Clintonville Business Association, and today, the Clintonville Chamber of Commerce. The Clintonville Conservation Club, Clintonville Boys Association, North Columbus JayCees, Civitan, Kiwanis of Northern Columbus, and innumerable other organizations have also made the community what it is today.

The women of Clintonville have been an important force. In the early 1920s, the women of Como Methodist Church threw themselves into fund-raising efforts to enable their church to erect its new building on North Broadway Street. Thirty years later, Gethsemane Lutheran Church women played an equally important role in that parish's development. The Clinton Child Welfare League (later known as the Clinton Social Welfare League and eventually just the Clinton League) held fund-raisers for children, war-relief efforts, schools, and libraries of the community. Beechwold's TWIG (Together With Important Goals) group has existed since the 1930s and focuses on raising money for the Nationwide Children's Hospital.

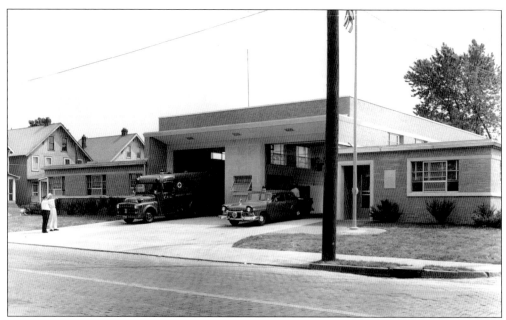

The original Engine House No. 13 was built in 1892 at the southeast corner of Wilcox and High Streets. A replacement station was constructed in 1957 at 309 Arcadia Avenue. By that time, the fire department had ceased to build two-story engine houses with brass poles. Engine House No. 13 is a one-story station with two apparatus bays in the center and living quarters on the sides. (Courtesy of Central Ohio Fire Museum.)

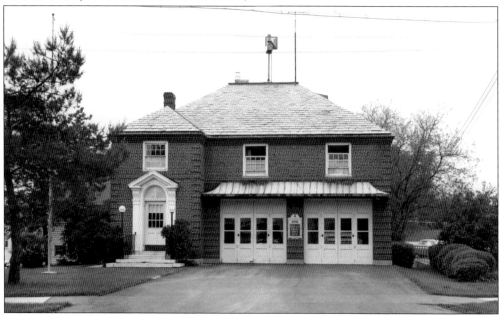

Engine House No. 19, located on the corner of Northmoor Place at 3601 North High Street, was dedicated March 10, 1931. It was the only engine house built during the Depression and was designed to blend into the neighborhood. In 2003, the firehouse was modernized and expanded to accommodate larger engine sizes, maintaining the architectural integrity of the original. (Courtesy of Central Ohio Fire Museum.)

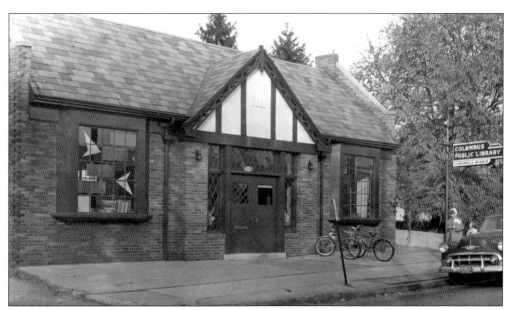

Clintonville's first library, a storeroom at 3317 High Street, was one of the first four branches in the Columbus public library system. It quickly became overcrowded. A grocer named Oscar Bilikam and his wife, Hattie, offered to build new quarters and rent them to the library for five years at $150 per month. The Bilikams's Clintonville branch library opened Monday, May 27, 1929, at 14 West Lakeview Avenue, just west of a Refiners' Oil Station. An open book is molded above the door, and children's book illustrations form a tile fireplace surround. The new quarters were expected to accommodate 10 years of growth, yet continued to serve as a library for 40 years. In 1969, the Clintonville branch library moved to 2800 North High Street (see page 77). The Clintonville-Beechwold Community Resources Center has occupied the West Lakeview Avenue space since about 1980. (Courtesy of Clintonville Historical Society.)

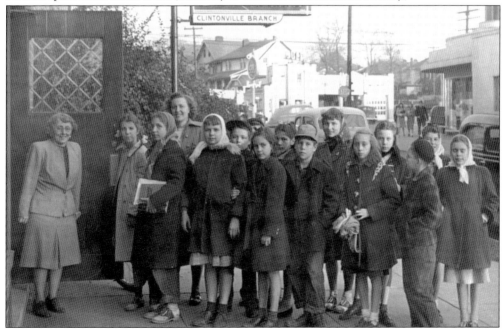

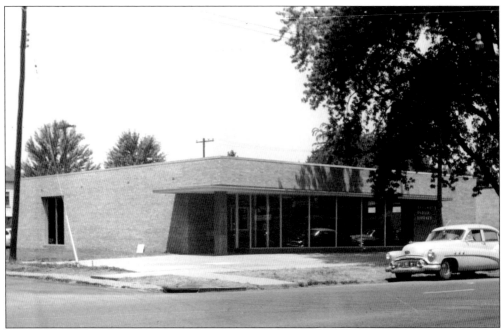

The Beechwold branch library opened August 2, 1954, at 4555 North High Street on the corner of Weisheimer Road. At 4,320 square feet, it was, at the time, Columbus's largest branch and cost $171,746.21 to build. Mildred Taylor, formerly of the Clintonville branch library, became its director and served until her retirement in 1972. (Courtesy of Clintonville Historical Society.)

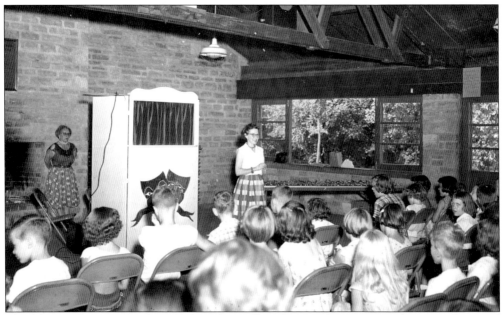

The library's Summer Reading Club traditionally culminated in an annual puppet show and party at Whetstone Park, shared by both Clintonville libraries. The photograph was taken in 1954, and the play that year was *Peter Pan*. On the left is Taylor, head of the Beechwold branch; on the right is Anna K. Alexander, Clintonville branch head. (Courtesy of Clintonville Historical Society.)

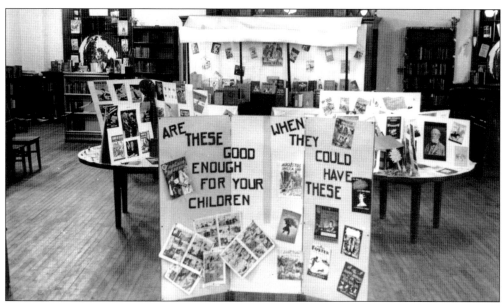

Children in the 1940s and 1950s were beguiled by comic books featuring Captain Marvel and other superheroes. The literary establishment was less keen on the genre; comics were thought to contribute to delinquency. This photograph shows a 1945 library campaign against comics in favor of real books. By 1954, opposition to comics culminated in a U.S. Senate investigation, and the content of comic books was subsequently censored for violence and sexual innuendo. (Courtesy of Clintonville Historical Society.)

In 1969, the Clintonville branch library moved to 2800 North High Street into quarters built by the Schottenstein Company. The library occupied the northwest end of the shopping center, which also had a Kroger and SupeRx drugstore. In 1985, the Clintonville and Beechwold branches were merged to become the Whetstone branch library at 3909 North High Street. (Courtesy of Columbus Citizen-Journal, Scripps-Howard Newspapers/Grandview Heights Public Library/Photohio.org.)

Perhaps Clintonville's most important institution, the *Booster*, was started by Rand P. Hollenback during the Depression to improve the business environment and, unabashedly, to boost Clintonville. The Press of Hollenback produced the newspaper at 3134 High Street from 1933 until the newspaper's sale in 1981. The newspaper and the Hollenbacks were the greatest force for giving Clintonville its political unity and its community identity. (Courtesy of the Robert Koch family.)

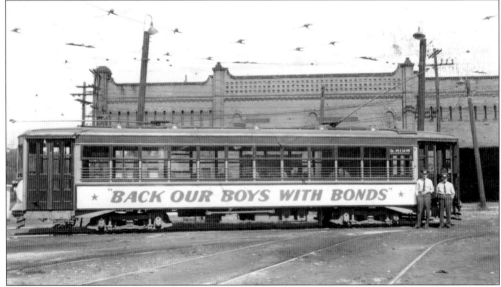

World War II affected every man, woman, and child in the community. The federal government marketed Series E U.S. Savings Bonds, sometimes called Liberty Bonds, to raise money for the war effort and control inflation during World War II. Streetcar driver Fred Dawson (right) and an unidentified driver stand alongside their streetcar advertising the sale of bonds in 1943, in front of the Arcadia Avenue car house. (Courtesy of Judy Cohen.)

Clintonville lost over 110 men and women in World War II. After the war, the Clintonville Woman's Club established Memory Lane, an *allé* of flowering crab apples along West North Broadway Street from the river to Olentangy River Road, each with a brass plaque memorial to a fallen soldier. (Additional crab apples were planted east to High Street later.) Kiwanis and other organizations also supported the project. The trees were removed when Route 315 was built, and the plaques were moved to Union Cemetery. The picture above shows Karen Kerchner by her uncle John Breunig's memorial during the 1950s. The photograph below shows the Kiwanis plaque. (Above, courtesy of the Kerchner family; below, courtesy of Franklin County Engineers.)

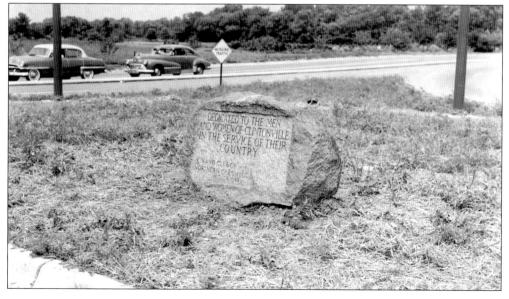

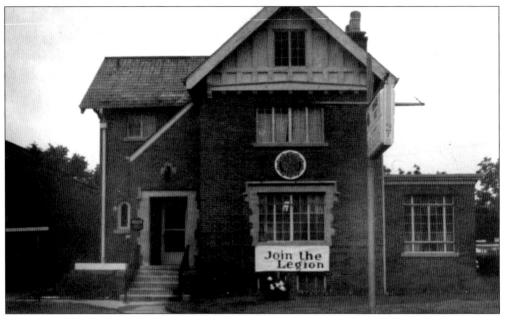

On October 23, 1919, the American Legion 136th Field Artillery Post No. 212 was granted a charter. In 1925, it consolidated with the Phillip Bruck Fleming Post to form Post No. 82. They met at 3526-½ High Street near Dunedin Road prior to 1948 and from 1948 until the mid-1990s at this Tudor Revival–style residence at 4604 High Street, where they adorned the front yard with a cannon. (Courtesy of American Legion Post No. 82.)

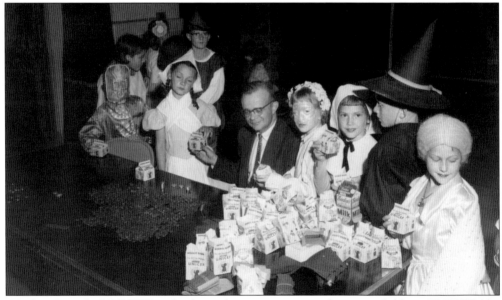

"Trick-or-Treat for UNICEF" is the first volunteer experience for many children. UNICEF (the United Nations Children's Emergency Fund) was created in 1946 to address the desperate needs of children in war-torn Europe. In 1950, some Philadelphia children donated $17 they collected on Halloween, and soon children collecting money in emblematic orange boxes while gathering candy became a national tradition. Here, children of Maple Grove Church in 1956 bring in their plunder. (Courtesy of Maple Grove Church.)

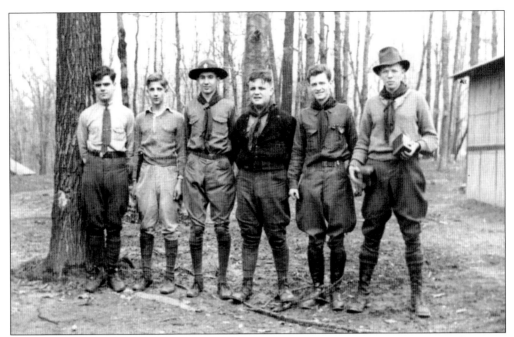

The oldest Boy Scout troop in the Clintonville area is Troop 28, which was chartered in 1918 and meets at North Broadway Methodist Church. This photograph shows, from left to right, scouts Dick Davidson, Dick Pontius, Paul Pontius, Ben James, unidentified, and Dave Weiss at Camp Lazarus in 1936. (Courtesy of Boy Scout Troop 28.)

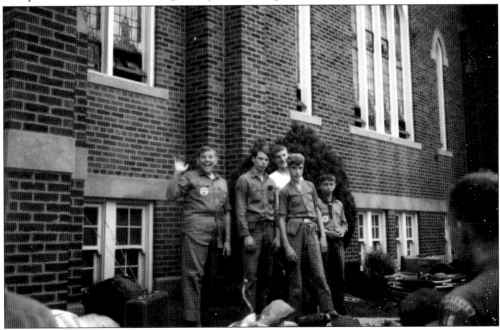

Crestview Presbyterian Church's Boy Scout Troop 46 included, from left to right, Mark Warner, Randy Wagner, Jim Duncan (in the white shirt), Jerry Duncan, and Bill Wolfe. Seen here in the early 1960s, they prepare to depart on their biennial out-of-town camping trip. This troop disbanded in the 1980s. (Courtesy of Martha Seelenbinder.)

Clintonville Conservation Club had a 40-year history in the community. Residents interested in conservation and outdoor sports started it in 1939. The club converted Northmoor Park into a fishing destination by building casting docks in the river and also contributing benches and tables. The club also sponsored camping experiences for local children and hosted educational programs. (Author's collection.)

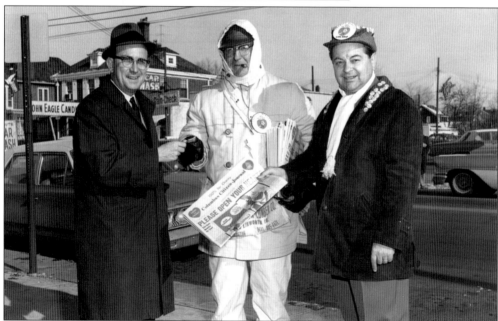

In 1907, several businessmen, all former newspaper boys, sold papers on behalf of a chilled young carrier at Broad and High Streets. It became an annual event. Charity Newsies hawk newspapers at busy intersections for donations every December. Funds clothe needy schoolchildren. In 1995, the organization's headquarters moved to 4300 Indianola Avenue. In this photograph, Carl Graf (right) and an unidentified Newsie solicit a donation from Robert Murray (left) at the intersection of Weisheimer Road and High Street in 1963. (Courtesy of Charity Newsies.)

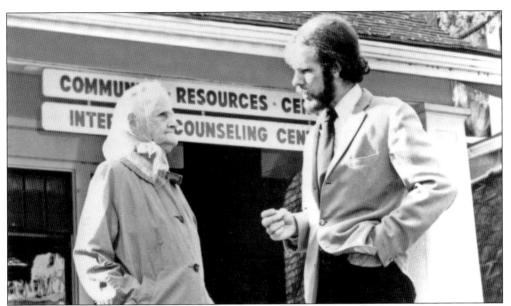

The churches of Clintonville are formidable community activists. In 1971, North Broadway Church and other local churches created the Clintonville-Beechwold Community Resources Center, a settlement house at 3175 High Street serving the needy in the northern part of the city. The first director was Bob Erickson, shown here with Clara Buechler in front of the center. In 1979 or 1980, the center moved to the former library at 14 West Lakeview Avenue and has been there since. (Courtesy of Robert Erickson.)

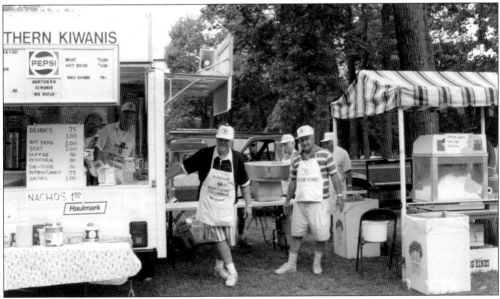

Kiwanis of Northern Columbus has been active in Clintonville since 1928. It has improved Whetstone Park, provided scholarships, sponsored teams, and, since 1963, sponsors the Whetstone Easter Egg Hunt. To raise funds, members have sold service newspapers, held breakfasts and fish fries, and sold concessions at community events. Dave Kerst, Dick Cleary, Bob Billups, Tom Miller, Ron Dill, and Don Dill worked the concession on the Fourth of July in 1995 at Whetstone Park. (Courtesy of Kiwanis of Northern Columbus.)

In 1939, six Clintonville women met to discuss the need for a cultural, charitable, and civic group. The result was the Clintonville Woman's Club, "to encourage wholesome community life, to promote acquaintance among women . . . and to secure cooperation in social, educational, civic, and welfare work in Clintonville." The Kiwanis Club donated land for a meeting place, and in 1965, the Clintonville Woman's Clubhouse at 3951 High Street opened. (Courtesy of Lynn McNish.)

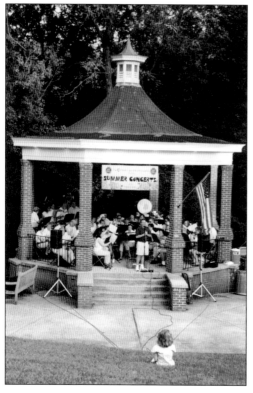

North Columbus Civitan assists people with developmental disabilities. Since 1953, the club has sponsored free summer concerts at Whetstone Park. This photograph was taken at a 2003 concert by the Clintonville Community Band at the Park of Roses gazebo. The gazebo, built in 1878 at Fort Hayes Military Reservation, was restored and moved to the Park of Roses in 1975 by Civitan and other organizations. (Courtesy of North Columbus Civitan.)

Six

SCHOOLS

"Schools and the means of education shall forever be encouraged." These words in the Northwest Ordinance of 1787, codified into the Ohio constitution in 1803, formed the beginning of Ohio's (and Clintonville's) school history. Authors of the ordinance believed in the importance of education and set aside Section 16 in each township to be used to fund education.

The first families of Clintonville organized schools in houses and in log structures. The first recorded schoolhouse located within present-day Clintonville was built between 1815 and 1820 across from Clinton Chapel. In 1816, the neighbors near what is now Henderson Road and High Street adapted an old stable for use as a schoolhouse and hired a teacher named Diadamia Cowles.

From about 1854 to 1873, there was a schoolhouse on the north side of Oakland Park Avenue near Fredonia Avenue. In 1873, a one-room brick schoolhouse was built just south of the intersection of East North Broadway and High Streets. This building stood until 1895 when it was replaced by a yellow brick four-room building. A schoolhouse was also built near Henderson Road and High Street, used for both worship and education, and another schoolhouse was constructed at 5218 North High Street. Overcrowding was a chronic problem for this growing community, and portable buildings—perhaps military surplus—were pressed into service throughout the community from its earliest years.

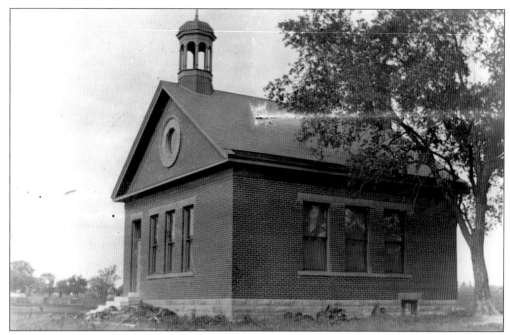

This former Sharon Township school is located at 5218 High Street. Cherry Hill School was a one-room school heated with a coal stove. There was a pump outside the building, an outhouse, and a small playground alongside the building. The cupola on the building no longer exists. (Courtesy of David Foust.)

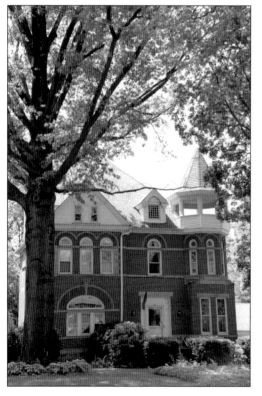

This building at 215 East North Broadway Street was built in the 1890s. During the years 1893 to 1896, the Clinton Township Board of Education rented it from James M. Loren for use as a school, which was called the Latin School. The students may have lived and had lockers on the third floor. (Courtesy of Lynn McNish.)

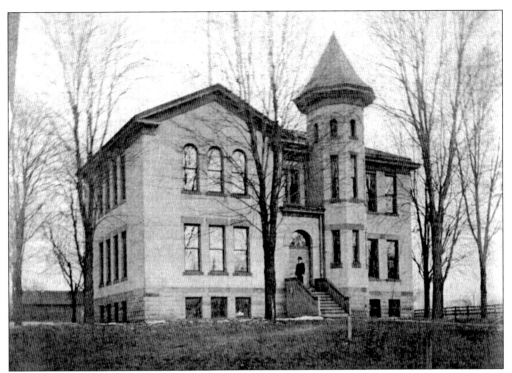

Originally there was a one-room redbrick township schoolhouse located on High Street near Clinton Heights Avenue. It was replaced in 1895 or 1896 with this four-room building. It served as both a grammar and township high school. Students stabled their horses behind the school. Each day, a student fetched water from the Chestnut house (see page 13) for student use. (Courtesy of Amy Westervelt.)

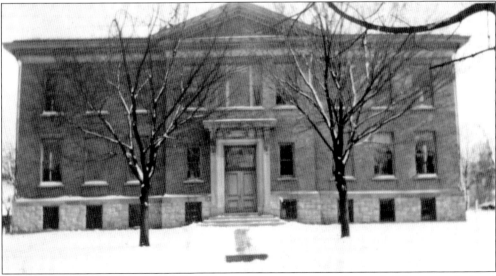

This 1904 structure, sometimes called Clinton Elementary School's east building, was designed by architect David Riebel. It served as the Clinton Township High School until 1910 when it was taken over by the city of Columbus. Between 1911 and 1915, it served grades one through 12; in 1915, it became an elementary school for grades one through six. (Courtesy of Amy Westervelt.)

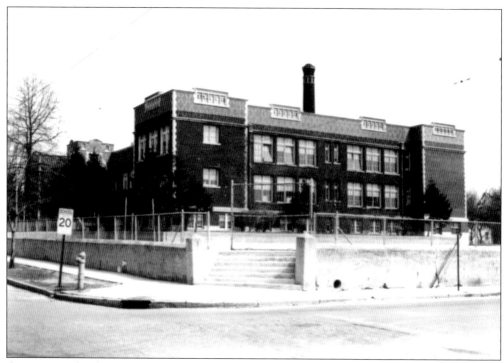

Crestview School opened in 1915 as Clinton Senior High School but within nine months became a junior high school. It was designed by architect by David Riebel. It was the first and only Columbus school to have an indoor swimming pool, an unpopular and short-lived feature. Over the years, Crestview has been an elementary, junior high, and middle school. This picture was taken in 1959. (Courtesy of Columbus City Schools.)

In 1935, the children of Crestview Elementary School performed a maypole dance in a May Day celebration. Each girl wore a dress made of crepe paper in various pastel colors, and they danced around the pole intertwining and plaiting the ribbons onto the pole. (Courtesy of Connie Fletcher.)

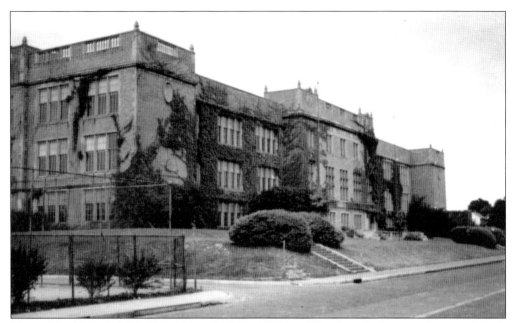

The original North High School was built in 1892 on West Fourth Avenue. A newer North High School building at 100 Arcadia Avenue was built between 1923 and 1924. It was designed by renowned Columbus architect Frank Packard in the American Tudor style. North High School's last class graduated in 1979; the school was closed as part of Columbus's desegregation and enrollment realignment plan. (Courtesy of Leeann Faust.)

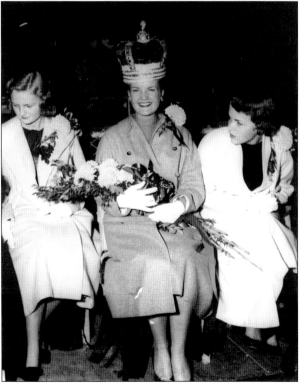

North High School had many firsts: it was the first Columbus school to have a Parent-Teacher Association (PTA), student council, student court, and National Honor Society; it was the first to have a night football game and to offer an all-night dancing party for seniors; and it also had the first homecoming queen. From left to right, this 1958 picture shows Mary Lee Corder, homecoming queen Carol Meider, and Sherry Tate. (Courtesy of Leeann Faust.)

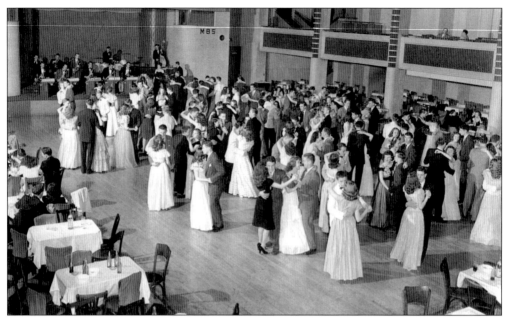

All dances are magic, and North High School's May 1947 Sweetheart Dance was especially so. It was probably held at the Valley Dale ballroom, a favorite place of students that was unofficially known as "North High School's country club." At a formal dance like this, men presented their dates with a corsage as soon as they arrived to take her to the dance. (Courtesy of Leeann Faust.)

In 1924, this bungalow-style house at 30 Webster Park was the Sherman Private School and an extension of the Morrey School of Music. The Sherman school offered music, physical education, and expression for kindergarten, first, and second grades. Alice Sherman was principal of the school and owner of the house. The school may have served as inducement to purchase in the area by the housing subdivision's developers. (Courtesy of Lynn McNish.)

Immaculate Conception Church had built a small wooden structure around 1916. In 1921, the church purchased a nearby house for use as a convent. Three of its rooms and two rooms of the church rectory were used for school purposes. A permanent school building was erected in 1925. In the picture to the right, two unidentified students from the class of 1924 stand alongside Rt. Rev. Msgr. John J. Fagan. They would have attended classes in both the rectory and the convent. The photograph below shows the original, old wood-frame building (right) and the school built in 1925. (Courtesy of Immaculate Conception Church.)

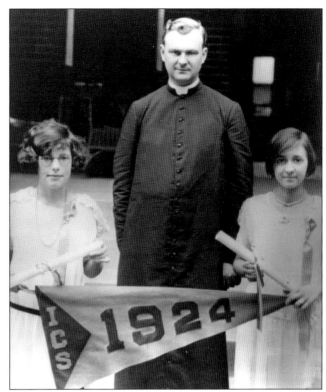

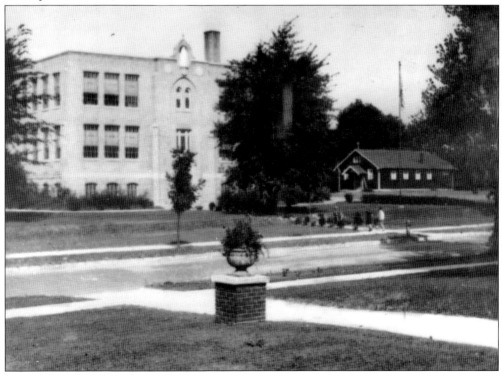

Portable schools were often used by the local school systems to address overcrowding. Glenmont Elementary School began in 1929 as a cluster of wooden portable schools, each having two classrooms divided by a hallway, on approximately seven acres of land at 470 Glenmont Avenue. Eventually the school comprised four portable schools. Each portable building had a stove for heat, and they all shared one restroom. There was a playground on the east side, purchased by the PTA. In 1952, a permanent brick building was erected for Glenmont (below), and the portables were moved on to Hamilton School. (Above, courtesy of Judy Morrison Robinson; below, courtesy of Columbus City Schools.)

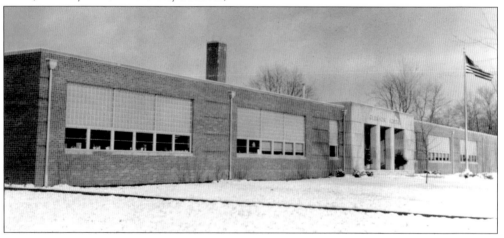

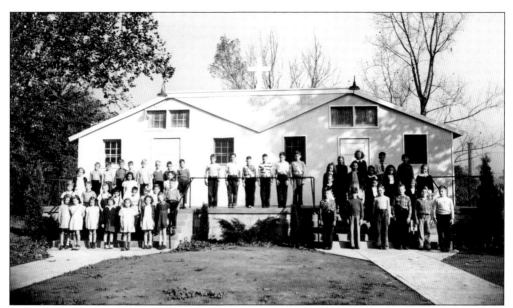

When Our Lady of Peace congregation organized in 1946, its quarters consisted of a rectory and convent, military barracks from the Marion Army Supply Depot, and a portable voting booth used as a kitchenette. A permanent school was built first, followed by the church. A six-room schoolhouse was dedicated in 1952, a temporary church was built in 1953, and a more permanent church was added in 1967. Here the 1947 students stand in front of their temporary school. (Courtesy of Our Lady of Peace School.)

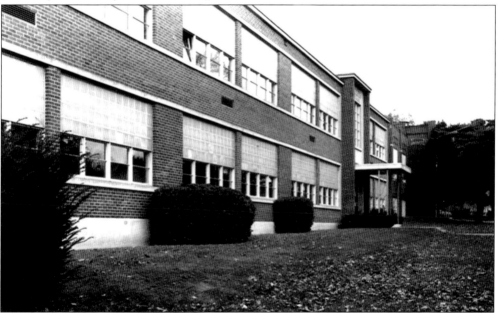

Homedale Elementary School, at 50 Westview Avenue, was built in 1925 for the Sharon Township school system. The Columbus Board of Education enlarged it in 1955. In 1979, Homedale was closed as part of Columbus's court-ordered desegregation plan. It was purchased by Grace Brethren Church of Columbus for its Christian school ministry, Worthington Christian Schools, and became Worthington Christian Westview Elementary School. (Courtesy of Columbus City Schools.)

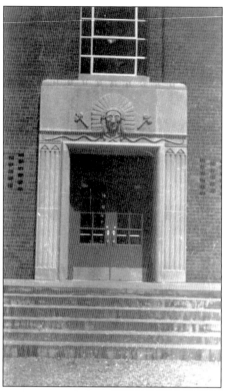

Indian Springs Elementary School opened at 50 East Henderson Road in 1950 with 547 students transferring from Clinton Elementary School and public school classrooms at Maple Grove Church. The school was built on the site of the Indian Springs Golf Club. The signature Native American over the door was inspired by a 1940s *National Geographic* image. (Courtesy of Indian Springs Elementary School.)

One of Indian Springs Elementary School's main events has been the annual Pow-Wow, sponsored by the PTA. Pony rides, makeup tables, pick-a-pocket ladies, fortune tellers, goldfish bowls, bake sales, games, prizes, and, of course, food are classic Pow-Wow activities. This photograph shows a Pow-Wow pony ride in October 1951. (Courtesy of Indian Springs Elementary School.)

94

Civic involvement begins at an early age. In this 1950 photograph, principal Floyd Heil confers with his Indian Springs Elementary School student council. Note the armbands council members, called "Indian Scouts," wore. (Courtesy of Indian Springs Elementary School.)

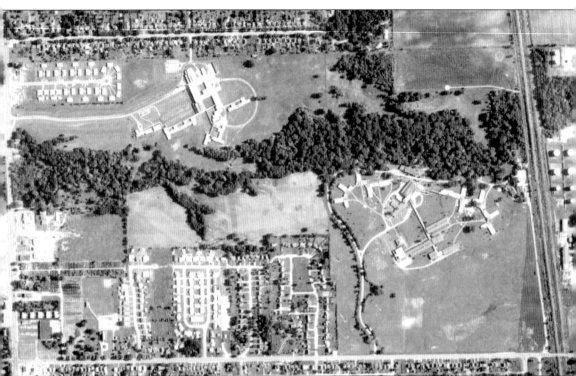

In 1827, the Ohio legislature established an Institution for the Education of the Deaf and Dumb, settling, in 1834, on East Town Street. By 1941, that facility was dilapidated, and the state purchased property on the far north side of the city. This site, originally the Wyandot Golf Course, contained wooded areas, grassy knolls, and a lovely ravine with a wide stream. Construction for the Ohio State School for the Deaf was delayed until after World War II and after the postwar state highway projects were finished. The School for the Deaf occupies the area south of the ravine. The new campus opened in 1953 and eventually contained 11 buildings with cottage-style housing for students. The aerial photograph is from 1957. (Courtesy of Franklin Soil and Water Conservation District.)

In 1837, the Ohio government established the first public school for the blind in the United States. Prior to 1953, it was located in downtown Columbus. In 1953, the Ohio State School for the Blind moved to the north side of the ravine previously occupied by the Wyandot Golf Course. In this photograph, students in the 1950s examine a teaching model of the Taj Mahal. (Courtesy of Ohio State School for the Blind.)

Bishop Watterson High School was built in 1954 by the Catholic Diocese of Columbus to serve the burgeoning population in Columbus's northern end. Though the building was not yet finished, the school opened its doors in 1954 to 166 ninth graders. This is a picture of members of the first class. (Courtesy of Bishop Watterson High School.)

The post–World War II baby boom called for more classrooms for children of all grade levels, especially high schoolers. Whetstone High School answered that need for the Clintonville area. Ground was broken in 1961, and the school was opened later that year. (Courtesy of Columbus City Schools.)

During the energy crisis of the late 1970s, Columbus Public Schools instituted a Schools without Schools program in which students were homeschooled four days per week. The following year, the school board announced plans to close Glenmont Elementary School. These incidents inspired parents at Glenmont to form an independent school. Clintonville Academy opened its doors in 1978 at 3420 Indianola Avenue. After two years, the academy moved into larger quarters at 3916 Indianola Avenue. (Courtesy of Clintonville Academy.)

Seven

THE WILD WOOD

Before 1800, the land now known as Clintonville and Beechwold consisted of oak, maple, and hickory forest, wooded gorges, and the Olentangy River. By the 1820s, farmland was overtaking the forests. In 1822, squirrels were so numerous and destructive of crops that there was a statewide three-day squirrel hunt and over 19,660 squirrels were killed.

Clintonville is graced with four ravines: Glen Echo, Walhalla, Overbrook, and Beechwold. The ravines lend natural beauty to the community and also have had utility: they were used as hiding places by escaped slaves; for extraction of clay by Clintonville's sole heavy industry, brick and sewer pipe; as a commercial draw to bring new residents and visitors to the community; and as a playground.

The river was a favorite skating spot in the early part of the 20th century. Children sledded on North Broadway Street and on Mooney hill in Walhalla Ravine. There was a swimming hole in what is now Whetstone Park plus a legendary skinny-dipping spot in the river at the Holt farm around Lincoln Avenue and High Street.

Clintonville now has several established parks. Clinton-Como Park was originally called the American Legion Playground, presumably because the playground was first developed by Post 82. Land for Northmoor Park was acquired in 1922. Delawanda Park, now called Kenney Park, was platted as a commonly owned park. Whetstone Park and the Park of Roses were developed in the early 1950s to provide recreational space to the northern Columbus area. The Olentangy Bikeway provides a bicycle corridor from north to south.

However, Clintonville has never been able to take for granted its green spaces. Much of Clintonville's green space has been consumed by housing. In 1953, a 400-foot earthwork was destroyed in the Overbrook Ravine area to make way for housing. In 1978, a developer proposed to fill in and commercially develop the Glen Echo Ravine near High Street. Beechwold and Delawanda residents sporadically battle plans to connect Bethel Road to Morse Road. Widening East North Broadway Street has been proposed several times. And Clintonville's green spaces are continuously endangered by the need for maintenance and the lack of funds and support to accomplish necessary projects.

The Olentangy River has always been an important focal point of Clintonville community life. The river served the Native Americans for transportation, and in modern times, its banks have seen grist- and sawmills, amusement parks, fishing, dams, and boating. Early white settlers called the river Whetstone River. The Ohio legislature changed the name to Olentangy River in 1833, either in error or because they supposed it to be the aboriginal name. This picture was taken around 1900 in the vicinity of Olentangy Park. A trail along the river bank continued for many miles at that time. (Courtesy of Library of Congress.)

Boating was a favorite activity. Olentangy Park offered a boat launch, and the Columbus Canoe Club, a private, all-male club, was located at the bottom of Orchard Lane. The club was in existence from 1897 to 1936. The clubhouse is today a private residence, and its original clay tennis courts have been converted to a swimming pool. Art McClearly is canoeing at the Orchard Lane put-in in the early 1920s. (Courtesy of Verna Rogers.)

David and Alta Korn built a home at 4891 High Street in old Beechwold in 1920. They had a son named William. The family was adversely affected by the Great Depression and lost their old Beechwold house in 1932. The photograph shows David and William fishing around 1928. William raised his family in Clintonville and died in 1986. (Courtesy of Clintonville Historical Society.)

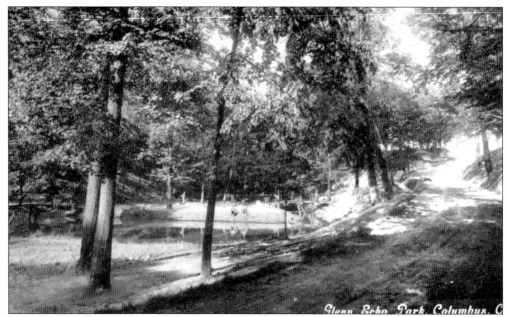

Glen Echo Park and the neighborhood that surrounds it were developed in the early 1900s. The Columbus Real Estate and Improvement Company had delineated 3.9 acres as a park and, in 1912, conveyed the land to the city. In 1922, a pedestrian stairway was built from Indianola Boulevard (now called Cliffside Drive). The park has cycled through periods of neglect and attention. (Courtesy of Stuart Koblentz.)

Mathias Armbruster purchased Walhalla Ravine in the late 1800s and subsequently sold 25 acres to a developer. Armbruster helped design the streets and named them and the ravine after Norse legends appearing in Wagnerian Ring Operas. This is how Walhalla Ravine looked in 1920. An artist owned the house on the right. (Courtesy of The Columbus Dispatch.)

Old maps show at least three "Indian springs" within Clintonville. Overbrook Ravine, one of the springs, was untamed and picturesque. Lore has it that Native Americans harvested cranberries along the brook. A common Sunday pastime included strolling through the area to visit the springs in the Overbrook area or riding horses along Clement Lane (now known as Indian Springs Drive). In the photograph above, Frank Westervelt walks along Overbrook Ravine with his future wife, Esther Ferris. Below, Westervelt shares a refreshing cup of water with his sister Edith Westervelt. (Courtesy of Amy Westervelt.)

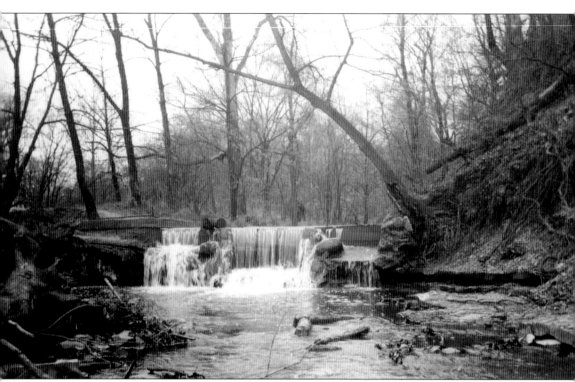

The Schwarzwalder family, who lived at 246 Glenmont Avenue, built this dam and waterfall on Overbrook Ravine for use as a swimming pool. At one time, it was possible to walk from one side of the brook to the other on top of the concrete, but the dam has since eroded and broken. The photograph was taken in January 1949. (Courtesy of Mary Bucher Fisher.)

When the Wyandot Indians were removed from Ohio to Kansas in 1842, 12 Native American families supposedly remained behind. Bill Moose was born to one of these families, and he lived in the Columbus area until his death in 1937. Moose lived in a small shack just south of where Morse Road intersects the railroad track. He roamed the woods and ravines of Clintonville, hunting, trapping, gardening, and befriending everyone he met. When Moose died in 1937, more than 10,000 people attended his funeral. He was buried just north of Griggs Dam. (Courtesy of Galen Gonser.)

In 1922, the Columbus Lodge of Elks constructed the Elks Country Club, located north of Morse Road east of High Street to Indianola Avenue. The clubhouse burned down in the winter of 1930–1931, and lodge members voted to give up the club. Some members chose to continue the golf course, and it was reopened under the name of Wyandot Country Club. (Courtesy of Betty Huber.)

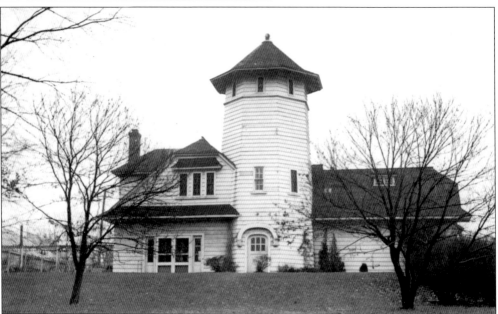

Under the grounds supervision of Lawrence Huber, Wyandot Country Club became one of Columbus's finest golf courses. This clubhouse replaced the Elks clubhouse after it burned down. The property was eventually sold to the city, which, for several years, ran it as a municipal golf course. In 1953, the land became the Ohio State School for the Blind and the Ohio School for the Deaf. (Courtesy of Betty Huber.)

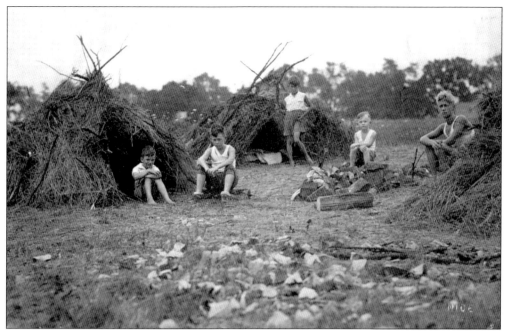

Wherever there was undeveloped land in Clintonville, children could be found annexing it for themselves. From left to right, Richard Knopf, unidentified, Bob Fowle, Dave Young, and unidentified—all children of the Indian Springs neighborhood—build huts near Dominion and Zeller Roads in the late 1930s. (Courtesy of William Dunning.)

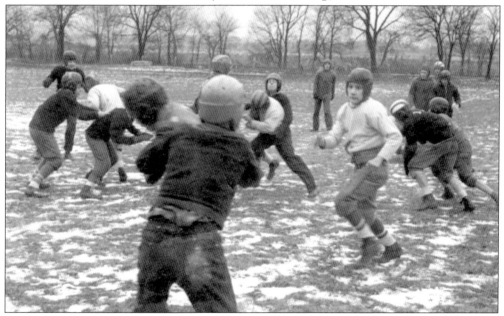

A Thanksgiving Day tradition, boys from Clintonville played an annual game of football on the abandoned fields that later became the Whetstone Recreation Center or on Como Playground. This photograph was taken around 1941. It is not known who won, but the players included Mark Thompson (white shirt), Roy Breunig (with his back to the camera), and probably also Jack Smith, Max Holzer, Al Schwarzwalder, and Joseph Breunig. (Courtesy of the Kerchner family.)

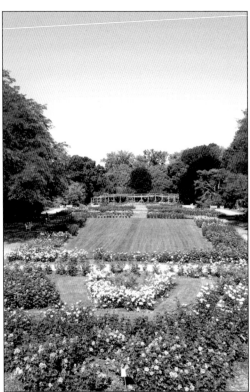

In 1952, the city developed 13 acres within Whetstone Park as a formal rose garden, and in 1954, the American Rose Society moved to it from Hershey, Pennsylvania. The society's headquarters and library were located within the garden at 4048 Roselea Place. In 1974, the society relocated its headquarters to Louisiana due to its longer growing season, and the building became a senior center. The rose garden remains a city showpiece. (Courtesy of Lynn McNish.)

From 1954 until 1974, a Maiden of the Roses pageant was held annually on Father's Day in the Park of Roses. Its goal was to bring people to the park; the weekend included a variety of activities and sometimes a community parade. The pageant was a scholarship competition awarded for civic and school involvement and "natural beauty." In 1961, the winner was Julie Bird from Worthington High School. (Courtesy of North Columbus Civitan.)

Eight

GOOD TIMES

A defining event in Clintonville's history was the purchase of Olentangy Villa Tavern and park by Joseph W. and Will J. Dusenbury in 1899, and the vision they brought to it.

Olentangy Villa had been a lovely location with great natural beauty just north of the community called North Columbus. Some people say the park was a sleepy little picnic park; others say the tavern was on the rough side. In any case, the park was relatively undeveloped. The Dusenbury brothers purchased the venue and over many years built it into a unique combination of exquisite natural surroundings, exciting rides, a zoo, a concert theater, a dance hall, and an all-around elegant entertainment destination. Riding the Columbus Street Railway Company's streetcar there, thousands of people thronged to the park each summer.

The park's heyday coincided with the beginning of real estate development in Clintonville. The traffic and business generated by the amusement park made the streetcars this far north of Columbus cost-effective, and existence of the streetcars made commuting from Clintonville to downtown Columbus feasible.

In the end, the Great Depression took its toll on Olentangy Park, and it slid slowly into decline. When the park eventually closed in 1938, it was open more than four decades.

By the time Olentangy Park closed, the southern part of Clintonville was a well-established neighborhood of Columbus. The first families of Clintonville had plenty of self-made entertainment available, including skating, sledding, buggy and automobile rides, swimming, knocking about in the woods, following ravines to their source, playing in the river, climbing on train trestles, visiting with neighbors, and taking long strolls on Sundays. Since a good book had no competition with television, they read, and libraries became an integral part of their lives. Everybody loves a parade, and Clintonville residents mounted their fair share of them. They actively gardened, put on their own concerts and plays, started clubs, and were involved with their churches.

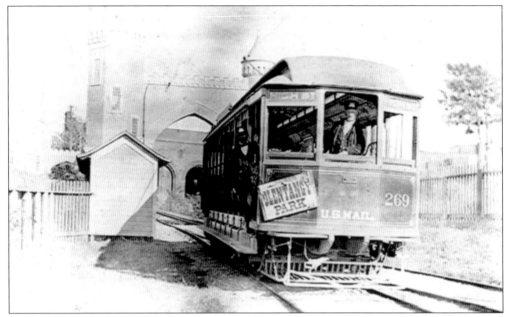

In the early 1890s, Robert Turner founded a tavern and park in Clintonville near Kelso Road and High Street called the Olentangy Villa. The Columbus Street Railway Company purchased the park in 1896 and renamed it Olentangy Park. The company generated both riders and attendees by running its streetcar line to the park. In 1899, Joseph and Will Dusenbury acquired the park, which was already renowned for its beauty. (Courtesy of Chris Bourne.)

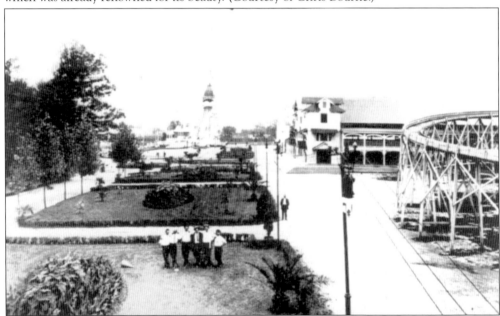

The Dusenbury brothers developed the 100-acre park. They added a restaurant and colonnade, a bowling alley near the river, a theater, a boat launch, a zoo, a Japanese village imported from the St. Louis Exposition, an amphitheater, a midway, roller coasters, and rides. The park was open only during the summer. From left to right, this photograph shows Shoot-the-Chutes, the dancing pavilion, and one end of the Loop-the-Loop ride. (Courtesy of Olentangy Village.)

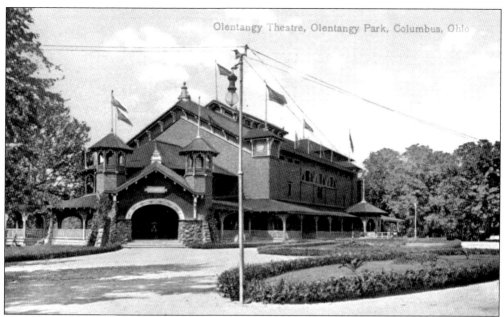

Olentangy Park's theater was billed as the finest and largest in America at the time. In the days before air-conditioning, the theater offered naturally cool air in contrast to downtown theaters that had to close during the hottest months. The park's theater featured some of the best theatrical and Vaudeville talent in the nation. Eventually downtown theaters installed air-conditioning, and the park's theater suffered from the competition. (Courtesy of Elio Santarelli.)

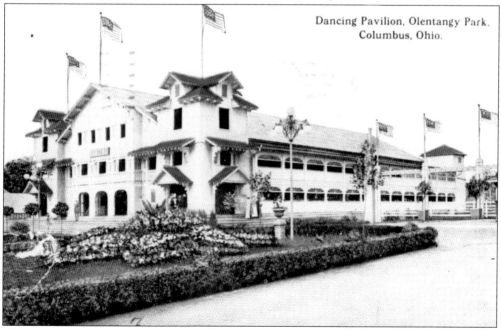

Dancing Pavilion, Olentangy Park, Columbus, Ohio.

The dancing pavilion, built around 1907, was said to be physically located half in the city of Columbus and half in the county's jurisdiction. At midnight, when city regulations required the dance hall to be closed, the dancers merely moved to the other half of the dance floor. (Courtesy of Olentangy Village.)

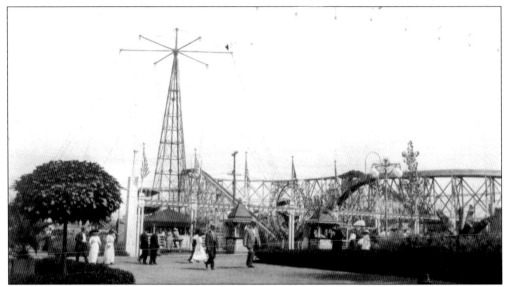

The Circle Swing was added to Olentangy Park in 1909, and this picture shows it around 1910 with the Loop-the-Loop and the scenic railroad ride in the background. Even though the setting is, by today's standards, quite casual, attendees dressed up in their best Sunday clothes for their park visit. (Courtesy of Chris Bourne.)

Columbus's 1913 flood caused extensive damage to the park's boat launch and the four-lane bowling alley within it. Instead of repairing the lanes, the park remodeled the boathouse to become the Olentangy Canoe Club. The boathouse burned down during the off season on March 30, 1934. (Courtesy of David Foust.)

In 1917, the Dusenbury brothers opened their new swimming pool at the park on the site of a former Japanese garden. It was 80 feet by 300 feet, the largest pool in the central United States. The pool continued to be used after the park closed in 1937. It was downsized to half its original size in 1938 and finally removed in 1999. (Courtesy of Chris Bourne.)

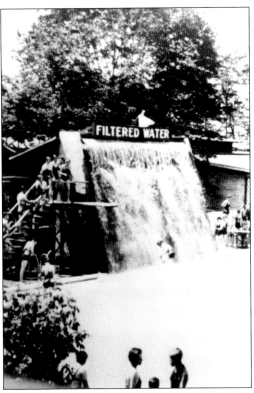

The park offered dances, concerts, musical revues, lectures, checker tournaments, pugilist matches, celebrity visits, PTA picnics, swimming, rides, pet and bicycle parades, and, of course, beauty contests. This photograph was taken on August 1, 1928. (Courtesy of Clintonville Historical Society.)

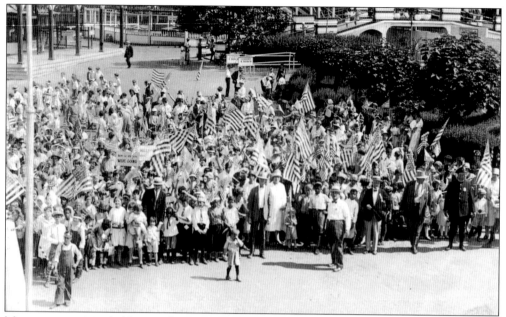

Many communities held annual picnics at the park like this 1920s Fourth of July picnic. As early as 1937, the Clintonville Business Association was hosting an annual picnic at Olentangy Park that included pet, doll, and bicycle parades. By 1940, it was held at the Columbus Zoo. Eventually the annual picnic was moved to Whetstone Park and a "new" annual tradition was born. (Courtesy of Clintonville Historical Society.)

Olentangy Park brought wonders and celebrities from around the world to Clintonville. In 1935, 11-year-old twins Louise and Louis MacMillan had a chance to meet Siamese twins Violet and Daisy Hilton. Born in 1908 in Brighton, England, the Hiltons were conjoined at the hip but shared no internal organs. (Courtesy of Louise Armstrong.)

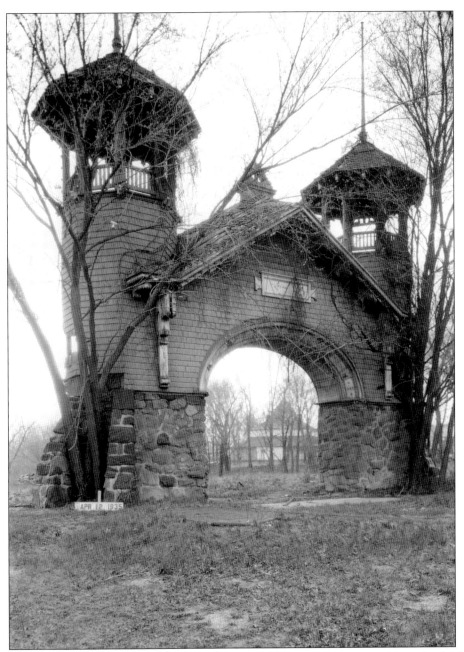

The Dusenburys suffered financial reversal, and in 1923, the park was sold to the highest bidder. In 1929, Leo and Elmer Haenlein acquired the park. The Haenlein brothers encouraged larger picnic days, and the park became an event destination. Nevertheless, it was the Great Depression, and the park declined slowly, building by building. The theater burned down in 1927; this picture shows what remained of it in 1935. The park's last season was 1937. Imagine the disappointment of the public eagerly anticipating the new park season, when, on April 1, 1938, the newspapers announced that it would not reopen. The park was sold to the L. L. LeVeque Company, which demolished it to make way for a housing development (see page 28). (Courtesy of Galen Gonser.)

"Facing the Music"

— Given by —

Maple Grove Dramatic Club

JUNE 5th and 6th

BENEFIT LADIES' AID SOCIETY

CAST OF CHARACTERS.

The Rev. John Smith.........................Cecil Myers

John SmithEarl Brown

Dick Desmond (John Smith's guest).........J. L. Armstrong

Col. Duncan Smith (John Smith's uncle)......Harry Webster

Sargent DuffellGlenn Coon

Mable (Rev. John Smith's wife).................Clara Cooke

Nora (John Smith's wife)Lucy Webster

Miss Fothering (an actress)Mrs. Earl Brown

Mrs. Pouting (The Housekeeper).......Mrs. Harry Webster

Act I—Breakfast Room in John Smith's flat at Kensington. 10 A. M.

Act II—Same as Act I. 10 minutes later.

Act III—Same as Act I. 20 minutes later.

In the absence of movies and television, people produced their own plays. Around 1910, Maple Grove neighbors formed the Maple Grove Dramatic Club to benefit the Maple Grove Civic Betterment Association. They produced two plays, *Facing the Music* and *Captain Racket*, and used, for their theater, the Hess family barn located between Deland and West Cooke Roads. The group had rehearsals, costumes, advertising, ticket sales, programs, seats, and even pre-cast parties. As many as 400 people attended. The show was deemed to be so good, it was taken on tour as far away as Lancaster. (Courtesy of the Ohsner family.)

Croquet was introduced to the world in 1851, and "nothing but tobacco smoke has ever spread as rapidly." Croquet quickly became a favorite form of family fun, perhaps because it was the first outdoor sport that could be played by both sexes on an equal footing. The Hollenback family played it on their farm near California Avenue and High Street. (Courtesy of the Richard Dawson family.)

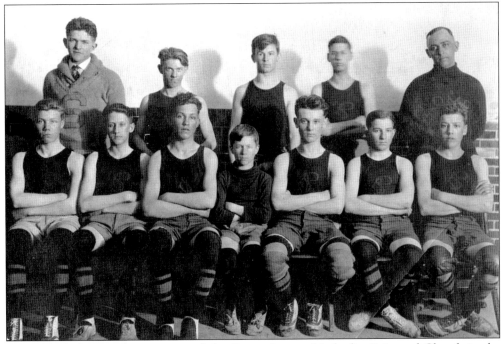

The basketball team that represented the Como Avenue Methodist Episcopal Church in the city's church league won the championship of the north section eight years in a row. Here they are in 1916. (Courtesy of North Broadway Methodist Church.)

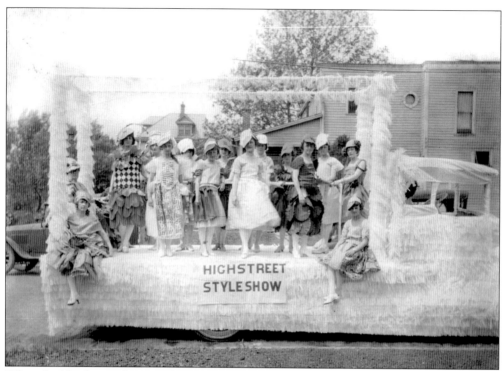

When the Northmoor housing development opened around 1921, all of Clintonville turned out to celebrate with gaily decorated floats for a community-wide parade. The North Side Field Day celebration became an annual event. In 1928, Clintonville had a fall Mardi Gras festival. It is not known whether this Clintonville celebration float was for one of these occasions, but it is likely. Mabel Westervelt, standing third from the right, is wearing an orange crepe paper dress. (Courtesy of Amy Westervelt.)

The sight of Caucasians covered with burnt cork singing "Mammy" is an unsettling reminder of the racial and cultural mind-set of a bygone era. Minstrel shows, popular in the United States during the late 19th and early 20th centuries, were musical revues that lampooned African Americans through jokes, impersonations, and songs. The Clintonville Greater Minstrels was sponsored by the Clintonville Business Association, and shows were put on at least twice, in 1934 (shown here) and 1935. (Courtesy of Clintonville Historical Society.)

In 1872, a group of prominent Columbus Republicans formed a singing and marching club to take part in the Ulysses S. Grant–Henry Wilson presidential campaign. Still in existence today, the Republican Glee Club has participated in inaugurations, conventions, and White House concerts. From 1929 to 2000, its clubhouse was located 57 East Weber Road—a building that, from 1925 to 1929, served as the Free Methodist Church. The house is now a private residence. (Courtesy of Lynn McNish.)

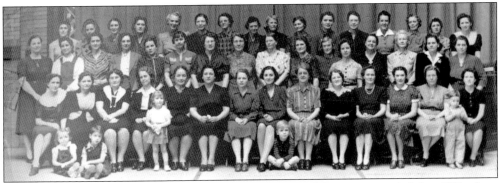

When Pres. Franklin D. Roosevelt formulated his New Deal, he recommended that PTAs form groups of "mothersingers" which, through their singing, would make those around them happy. In 1936, a group of 18 women from the Clinton Elementary School PTA formed a choral singing group. Over the years, the Clintonville Mothersingers group has rehearsed at various schools and performs 12 concerts a year. This photograph shows the group in 1941 or 1942. (Courtesy of Virginia Secrest.)

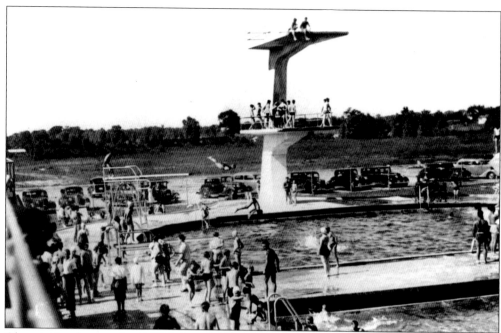

Olympic Beach opened at 3450 Indianola Avenue in 1938, and Orr S. Zimmerman purchased it shortly thereafter. The pool offered a "futuristic-designed swimming pool with night swimming, sand and grass-terraced beach," three pools, and a 32-foot diving platform. The pool was used by Olympic teams, the Ohio State University swimmers and divers, and the community. The Zimmerman family owns the Olympic Swim Club to the present day. (Courtesy of Michael and Carole Tomko.)

In the early 1970s, the Zimmerman family demolished a car wash north of their pool and built tennis courts in its place to form the Olympic Racquet Club. Three years later, they covered the tennis courts with bubbles for year-round tennis. Note the Anderson Concrete Company to the rear of the courts. (Courtesy of Jim Criswell.)

Olentangy Village Bowling Lanes opened in 1940 at 2815 High Street. Sanders Frye, a local resident, is said to have invented one of the first automatic bowling pinsetters, and these were installed at the lanes in the mid-1940s. Bowling alleys were, during this era, important destinations for teens; even when they did not bowl, they hung out regularly at the Olentangy Village lanes. A fire destroyed these lanes on October 27, 1980. (Courtesy of Olentangy Village.)

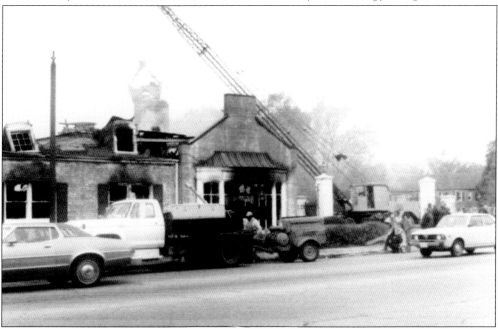

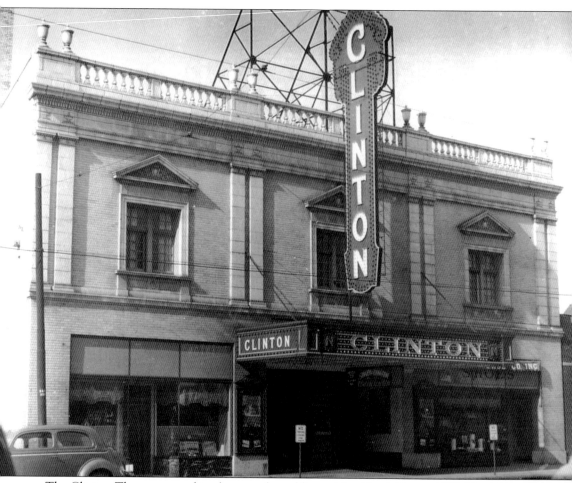

The Clinton Theater opened its doors to the public on New Year's Day in 1927. The lobby was finished in green marble, and the 1,500-seat auditorium was domed by an elliptical ceiling of twinkling stars. The general color scheme included reds, greens, golds, and grays, and the theater had quality stage equipment and a large stage. The theater changed ownership several times; this picture shows it around 1939. It ceased operation in 1973. (Courtesy of Ann and Alan Woods.)

The Beechwold Theatre opened in 1941 as a 900 seat single-screen cinema located at 4250 North High Street. Originally designed by Fred Stritzel, it was remodeled to become the Camelot North (an Academy Showcase theater) in 1972 and became the Drexel North in 1986. It closed in the spring of 1995 after 54 years of movies. The edifice was converted into a drugstore and later a fitness center. (Courtesy of Leeann Faust.)

The Indianola Theatre opened in 1938 at 3055 Indianola Avenue with the movie, *The Stage Door*. It has been continually running movies ever since, though it has changed ownership and names several times. In the early 1960s, Jerry Knight briefly leased the theater, renamed it the Fox, and, to the dismay of the neighbors, showed sexploitation films. The theater became Studio 35 in 1965. (Courtesy of Phil Sheridan Archives.)

2nd BIG WEEK!
Hi, There! Need a handyman?

MIDWEST PREMIERE SHOWING

"EVE AND THE HANDYMAN"

STARRING GORGEOUS EVE MEYER (Playboy's Playmate) and ANTHONY RYAN (as the handyman) IN COLOR

A DELIGHTFUL COMEDY BY THE SAME MISCHEVIOUS MOVIEMAKERS WHO MADE "THE IMMORAL MR. TEAS". IF YOU LIKED TEAS, YOU'LL LOVE THE HANDYMAN! SHOWS CONTINUOUS BEGINNING AT 7 P.M. NIGHTLY AND 2 P.M. SUNDAY. STRICTLY ADULTS ONLY.

3055 INDIANOLA
● AM. 7-0545 ● **indianola**

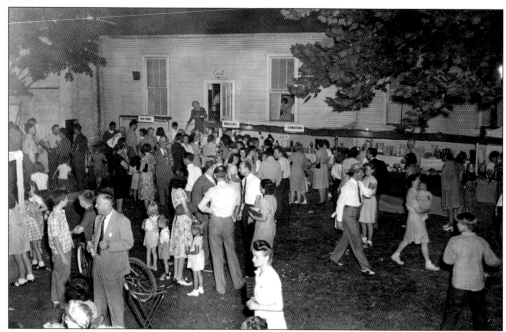

Churches throughout Clintonville have always had dinners, carnivals, picnics, and social gatherings. This photograph shows Maple Grove Methodist Church's annual church bazaar sometime in the 1950s. It was a time of good friends, good food, and good fun. (Courtesy of Maple Grove Church.)

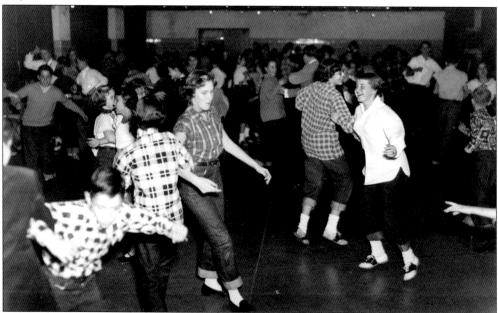

Dancing is an ever-popular form of entertainment among young and old. During the 1950s, community leader Harold Dawson introduced square dancing to the community at churches, schools, and the new recreation center. He also introduced sock hops and North High School's overnight dance party for senior prom night. This photograph shows a square dance at Maple Grove Church in 1951. (Courtesy of Maple Grove Church.)

The Kiwanis Club of Northern Columbus, with Columbus Recreation and Parks, began sponsoring a community Easter Egg Hunt in Whetstone Park in 1963. Clintonville children have been searching for eggs ever since. (Courtesy of the Kerchner family.)

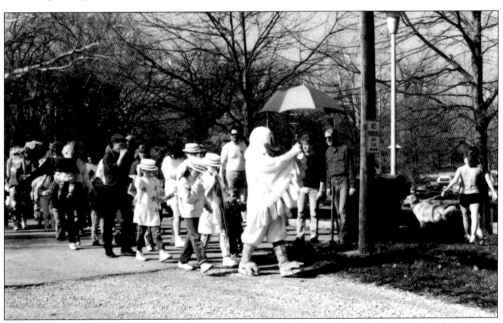

Duckling Day began in 1987 to celebrate spring and Ohio author Robert McCloskey's book *Make Way for Ducklings*. In the book, Mrs. Mallard leads her ducklings through a park in search of a suitable home. The parade, patterned after a similar one in Boston, mimics the duck family's walk. The Whetstone branch library holds the parade in conjunction with the Kiwanis Egg Hunt. (Courtesy of Columbus Metropolitan Library.)

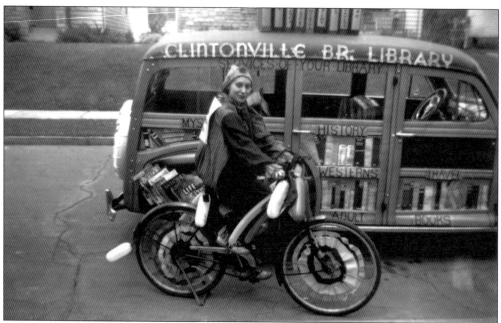

The staff of the Lakeview Avenue library are preparing to participate in a parade with a "bookmobile" in the 1950s, possibly for the Fourth of July. (Courtesy of Clintonville Historical Society.)

During the mid-1950s, the Clintonville business community sponsored contests for children at Halloween. Children could paint a window of a business for the holiday, and the best window dressing won a prize. The children cleaned up the windows afterwards. This decorated window was at the Graceland Shopping Center. (Courtesy of Casto Corporation.)

During the 1950s, Santa Claus made a pre-Christmas trek to Columbus schools and handed out candy to eager youngsters. *The Columbus Dispatch* newspaper apparently had some influence in the matter. This photograph shows Santa arriving on his sleigh at Clinton Heights Elementary School in the mid-1950s. (Courtesy of the Robert Koch family.)

www.arcadiapublishing.com

Discover books about the town where you grew up, the cities where your friends and families live, the town where your parents met, or even that retirement spot you've been dreaming about. Our Web site provides history lovers with exclusive deals, advanced notification about new titles, e-mail alerts of author events, and much more.

Arcadia Publishing, the leading local history publisher in the United States, is committed to making history accessible and meaningful through publishing books that celebrate and preserve the heritage of America's people and places. Consistent with our mission to preserve history on a local level, this book was printed in South Carolina on American-made paper and manufactured entirely in the United States.

This book carries the accredited Forest Stewardship Council (FSC) label and is printed on 100 percent FSC-certified paper. Products carrying the FSC label are independently certified to assure consumers that they come from forests that are managed to meet the social, economic, and ecological needs of present and future generations.

FSC
Mixed Sources
Product group from well-managed forests and other controlled sources

Cert no. SW-COC-001530
www.fsc.org
© 1996 Forest Stewardship Council

Find Your Place in History.